BOLDER

BOLDER

~

LIFE LESSONS FROM PEOPLE
OLDER & WISER THAN YOU

Dominique Afacan + Helen Cathcart

Hardie Grant

BOOKS

CONTENTS

HOW TO
GROW OLDER

WHO WANTS TO BE OLD? The sad and sorry onslaught of false teeth, withering skin and narrowing career options, followed by death as the ultimate full stop. What's to like? Youth is king. Who needs life experience and wisdom when you've got glowing skin, a body to thrill and decades ahead of you? Switch on your TV or read a magazine as adverts and culture propagating the anti-age message seep into your subconscious. Ageing is bleak – or so the conversation goes. Fight it. Or at least die trying.

Ageism is out there. It's ingrained in our culture. And it starts early. As women, we're constantly reminded of our biological clocks; we're asked why we're still single or why we're childless. We are all sold creams, gels and miracle cures to change the way we look. Trying to defy nature has become a multi-billion-dollar industry – and most of us are on board. Older people past a certain age are often seen as a drag on the nation's resources, of little value to the workplace. After all, they're stuck in their ways, they're out of touch, they're weak. Even our road signs for the elderly show a couple hunched over, one with a walking stick, vulnerable as could be. Together, we've learnt to dread the ageing process and everything that it means.

For us, both in our mid-30s, ageism had already won. We were scared of getting old. Terrified, in fact. And who can blame us? Old age looked like an unhappy place. We pictured it mostly filled with loneliness, rocking chairs and possibly some tea and biscuits, if we were lucky. Our present lives were vibrant, energetic, filled

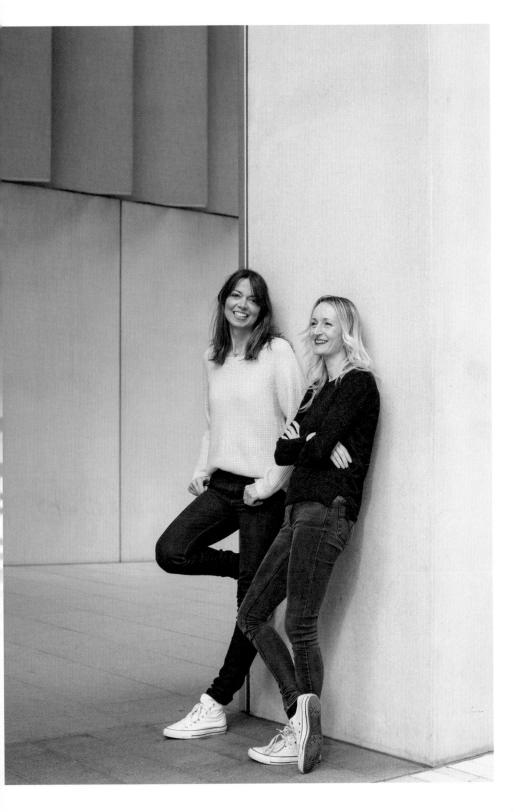

with travel, friends, new experiences, love and liveliness. When was old age going to knock on our door and tell us the fun was over? When would we stop being relevant, attractive and heard? Our happy days felt numbered, the dread of ageing was creeping in, so we decided to do something about it.

We set about finding people who made old age look good. Bolder was born. Four years and 50 interviews later, we've realised there is never a knock on the door. Old age doesn't just 'happen' one day. Ageing is a constant and a privilege for all of us. And ... gasp, it can be fun. One of our interviewees fell in love and married, aged 82. Another swims a mile in the Mediterranean every morning, aged 85. Nearly all of them are still working or creating in some way. So many of them cite the happiest age of their lives as now, not then.

For us, both with over a decade of experience of working in the media industry, the whole process of meeting our subjects was refreshing. For once, we could turn the focus away from the hot, young things we'd been confronted with for our entire careers and turn the camera in a new direction. There was no make-up, no lighting, no call sheet. Our interviewees were often far more comfortable in themselves than many of the models we'd worked with who were a fraction of their age. Even rare displays of vanity were coupled with a sense of humour: a realisation that it was all slightly ridiculous. In our era of pre-rehearsed press interviews, here was a group of people who, for once, weren't pushing a product and weren't accompanied by a PR manager monitoring every word. As such, they didn't care one bit about saying the wrong thing – and, my goodness, they were so much more interesting for it. We'd frequently stay for one more coffee or accept an invite to stick around for lunch and, in one case, an impromptu swimming lesson.

Often, our interviewees would find it hilarious that we were worried about getting older. They'd dismiss our worries with a wave and laugh away our fears. Single at 36?

'Lucky you!' came one response. Worried society is ageist? 'Stick two fingers up!' They were genuinely shocked that we could already be scared about ageing; perhaps not surprising given that our subjects were generally older than the two of us combined. We'd leave interviews on a high, bolstered by their enthusiasm for life and infected with their energy, which often felt more youthful than our own.

So are we cured of our fear? Not 100 per cent. We might occasionally be appalled at the appearance of more grey hair, and the idea of approaching 40 is sometimes alarming. But there's been a shift, because we've seen the other side. Where once we feared old age, now we respect it. The deadline on our happiness was self-imposed. And a good job, too: this year there will be a million new septuagenarians alone, more than ever before. Living until 90 and beyond is soon to become the norm, rather than the exception.

Of course, we can't get carried away. Ageing inevitably has its hindrances and its hiccups. Death, for one, draws ever closer, and nobody wants creaking bones and thinning hair. But we are already, collectively, fixated on the negatives. Through Bolder, our mission is to change the conversation by highlighting the much more positive flip side of growing older. This book is full of real people, not acting anything like their media-prescribed age, telling their inspirational stories. They sit among the society-wide scaremongering, demanding to be seen and heard, changing the dialogue on ageing now and for our futures. They are anything but invisible.

The best part of it all? Now that we've stopped to listen, there's so much to learn. What follows are some of our favourite lessons.

DOMINIQUE AFACAN & HELEN CATHCART ARE THE CO-FOUNDERS OF BOLDER.
WWW.BE-BOLDER.COM

LOVE

&

SEX

'HOW'S YOUR LOVE LIFE?'

Words to ruin a perfectly happy day if you're single – and if you're nudging 30 (or, God forbid, 40), well, you might as well give up now. Society does not take kindly to people who have missed the imaginary deadline on finding love, settling down (or merely settling) and living happily ever after. Nobody wants to be the lonely cat lady. Or the eternal bachelor for that matter – for men don't escape unharmed either.

As women, we're constantly reminded about that ticking fertility clock and that soon it'll be a case of 'Ding-dong, your eggs have gone!'. How utterly terrifying. Is it any wonder we often feel that love is a young person's game? Well, here's a happy Bolder newsflash: it's all total bullshit.

The imaginary deadline on love – set by us, set by the media, set by anyone else we wish to blame – is just that. Imaginary. Who knows why we've ended up believing there is one sure-fire route to love and that it ends at 30. Or why we've unfairly pinned men as a species who can't possibly fall in love when the object of their affection

has even the hint of a wrinkle. Before we started Bolder, we'd occasionally spot an old couple in the street, holding hands. Obviously childhood sweethearts, we thought. Together forever, how beautiful. Cue that sinking feeling in the stomach, then rising panic and that sense of having missed the boat. Bolder changed all that. Because, guess what? That couple, holding hands in the street, they met last week. They fell in love, aged 76, after two failed marriages. They met on a dating app. And – they still have sex.

Thanks to our interviewees, we've learnt to say no to the so-called 'normal' boundaries of love. Because now we know that the happiest people are those who have made their own rules. Pat Moorehead, our skydiving superhero, met his wife, Alicia, in his 50s. They were both travelling the world at the time – happily single. Many of our interviewees were alone and yet not lonely. Muffie Grieve, our Canadian tennis champ, loved life so much that a partner was not an answer, just a happy addition. A way of thinking to live by, and now we do.

RITA
GILMORE

Rita Gilmore owns a restaurant on Alderney in the Channel Islands. When she's not running up and down the stairs serving customers, she sings in a choir and models for her local dress shop.

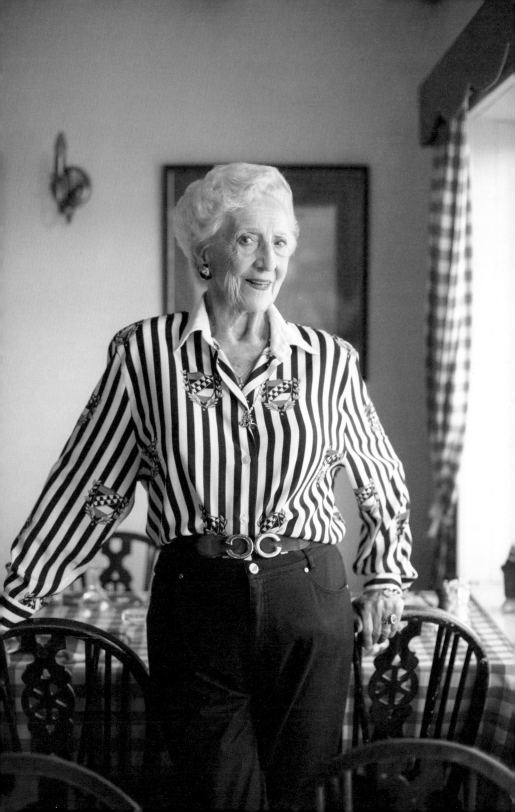

RITA GILMORE

> **I WAS BORN AND BRED IN DEAR OLD DEVON,** but I ended up in Alderney after they bought the breathalyser test to the mainland. Overnight, the pub I was running with Morris, my then-husband-to-be, collapsed as nobody could reach us without a car. Eventually, we found a pub for sale in Alderney – it was a broken-down, old dump, but it was cheap, so we made the move. Luckily, it was a success. I was only about 35 at the time.

Morris had a massive heart attack at 74, even though he was as fit as a fiddle. When you lose your partner, there's a big void, and you have to make the decision to start a new life for yourself. We got along extremely well, even though I hated the sight of him at the beginning! He was short and stocky, and I was taller than him, especially in my heels, but kindness and a sense of humour are far more important, and he had both of those in spades. He absolutely loved life. I still believe the secret to a happy marriage is lots of sex!

After Morris died, I chose to carry on the restaurant, and I think it has been good for me. People know who I am and there's a real family feeling. The stairs here have kept me physically fit, too. There are 16 of them, and I am up and down them every five minutes. I've kept trim because of that, although I've always looked after myself. I am not a drinker and I don't smoke. I used to when I was young, mind you – I'm not a stick-in-the-mud! I still love a glass of bubbly, but in the restaurant business you can't afford to get drunk out of your mind. I also add up all the bills longhand – I don't use a calculator, as I want to keep my brain active.

I actively choose to enjoy being 87 as I realise how lucky I am to be fit – lots of my friends are dropping off the perch, which is sad. I know I have to make the most of my remaining time. I'm not going to become a doddery old fool! I belong to a choir on the island and it's super – we've just been to Guernsey for the weekend to sing,

"I still believe the secret to a happy marriage is lots of sex!"

which was great fun. I've also got friends in their 30s and 40s, who invite me for Sunday lunches and things – it's good to mix with younger people. I think they like me for the stories I tell.

I suspect people admire me for still doing what I do and looking the way I look. I am not a pretty woman by any means, but I make the most of what I've got and I dress accordingly. You can't let yourself go when you're older. I often look at people who are younger than me and think how much better I could make them look! I have my hair done every week, I wear make-up every day and I even do modelling for the local dress shop.

I've never regretted anything as I've had lots of fun and I've crammed everything in. Lots of bad things have happened of course, but I've tried hard and changed my luck. You've got to make the most of life, no matter what it throws at you. If you're miserable, nobody wants you; you really have to make up your mind to have a bit of a laugh and be happy, otherwise you become a strain on people.

My life motto? Never feel sorry for yourself and never give in.

PAT & ALICIA MOOREHEAD

87 & 72 YEARS BOLD

Los Angeles-based skydivers Pat and Alicia Moorehead both hold multiple skydiving world records and between them have made almost 10,000 jumps.

DP+H We met Pat and Alicia, our skydiving record breakers, at their beach house in Los Angeles. Given their penchant for jumping out of planes, we thought theirs would be an interview that revolved around health, fitness and extreme sports. It did start out that way, in fairness, and they filled us in on all of their latest adrenalin-fuelled adventures as we photographed them in their gear on a windy Seal Beach. But after we were done and went back to their house for coffee, a love story emerged, which made even more of an impact on us than their skydiving exploits.

Up until the age of 53, Pat hadn't believed in love at first sight; then he met Alicia. And far from being a smug, schmaltzy couple, theirs felt like a true partnership, the sort perhaps both of us might one day hope to have.

Like us, Alicia was fiercely independent and had been happily single before she met Pat. The idea of being judged for that – or for choosing not to have children – hadn't even crossed her mind. That was huge for us. We wasted such a lot of energy on other people's opinions, real or imagined. She wasn't waiting around for Mr Right. For us, it made their partnership all the more genuine. There had been no mad rush to tie the knot, no biological clock prompting her to settle and no so-called 'normal' life she was trying to fit into. They found each other, and their lives were richer with the other in it. Neither had to forfeit their independence in the process.

Here, miles from home, talking to a couple we'd found via a Google search, we discovered a relationship model we could aspire to. A higher love, in all respects.

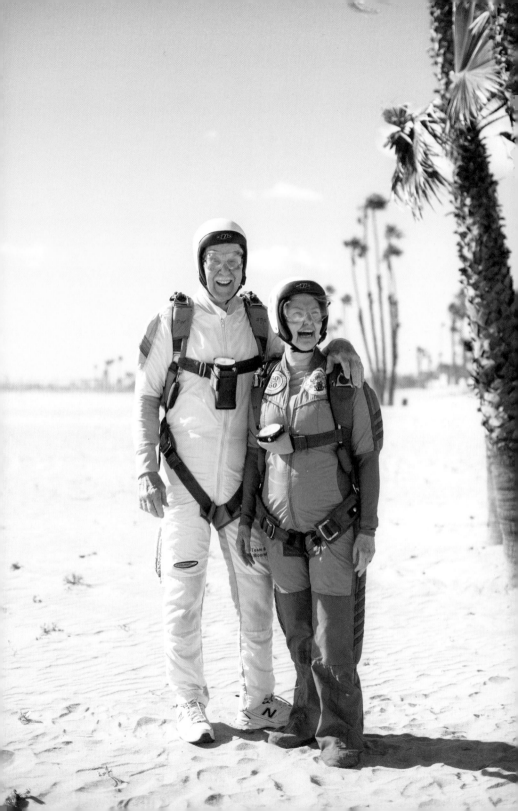

PAT MOOREHEAD

> **I DECIDED TO GIVE SKYDIVING A GO WHEN I WAS 37.**
> I made two jumps on my first day and I've been doing it ever since.
> Had somebody told me back then that I'd still be jumping aged 87,

I'd have said they were joking. For a start, I wouldn't have thought anyone would live to be that old! Now, 60 is the new 30.

When I turned 80, I decided to try making 80 jumps in a day. I was able to do it in six hours and broke a world record – I did one jump every 4.55 minutes. It's not all about 'the actual' skydiving though, it's about what you can do with the sport. It's very social. If someone offered me a plane for the day and said I could do as many jumps as I wanted, I wouldn't do it. It would be pointless. Planning the jump and making the jump and then talking about it is a major draw. There are people from all walks of life who do it.

Ageing well is all about attitude. When we bought our house, I remember looking at the stairs and thinking, 'Will I want to be walking up and down those stairs in my 80s?' The answer turned out to be yes. I don't even use the banister as then you aren't using your balance. I also have an exercise bench and free weights and do sit-ups and stretches and whatever it takes to develop the stamina and strength to jump.

I'm a great believer in what goes around comes around. There was a time in my life when I wasn't the same person I am now – I paid for that. If you put out good, for the most part, it'll come back to you. You have to be kind to everyone you meet – but also kind to yourself.

I thought love at first sight was something you read about in a magazine, but when I met Alicia, it was pit-a-pat right from the beginning. Ours is a partnership. There is no boss. We take good care of each other, we encourage each other and we support each other. We are simultaneously independent and dependent.

My life motto? There is no past, there is no future, so the best time is now.

"WE TAKE GOOD
CARE OF EACH
OTHER, WE
ENCOURAGE EACH
OTHER & WE
SUPPORT EACH
OTHER. WE ARE
SIMULTANEOUSLY
INDEPENDENT &
DEPENDENT."

ALICIA MOOREHEAD

I STARTED SKYDIVING AT THE RIPE OLD AGE OF 30 on the cornfields outside of Chicago. I was a gymnast all through grammar school, high school and junior college, and flying through the air sounded wonderful. I took my first class and within a week I'd done seven jumps. I just loved it. I was also a skier, and I've taken some big tumbles in the snow. After I'd jumped a few times, I realised I could tumble in the air and not get hurt. I thought that was pretty cool. Eventually, I moved to California so that I could jump more, as Chicago got pretty cold.

Jumping in different places around the world is fun – I explore new countries like people explore stores in the mall. I don't need a base. My house is just where I pack – a holding pen. One of my most memorable jumps was from a Royal Jordanian Air Force aircraft onto the Wadi Rum desert in Jordan. When we touched down, we were picked up in a four-wheel-drive jeep and taken for dinner in a Bedouin camp.

I met Pat through skydiving, but to be honest I was totally happy being single. I wasn't waiting for anyone. I don't lead what people might think is a normal life, and I would never want to. I have never wanted children. There may have been a stigma about that once, but not in California. I have close girlfriends who are single and who don't have kids, too. Pat and I don't argue – to be honest, there's nothing to argue about. We're both fit and healthy, and I've got tonnes of interests.

For my 70th birthday we went to jump in Utah for three days. I love deserts. Wide, open spaces like that are just alluring to me. Cactus bloom in the spring is unlike any other – those neon colours, the brightest pinks and purples and yellows that you'd ever want to see.

My life motto? Stay involved, stay curious. There is so much to see in the world.

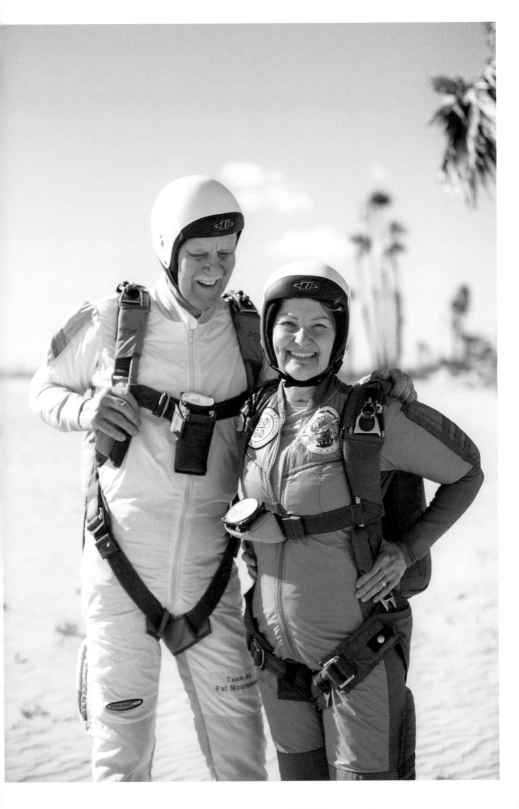

ELLERY MCGOWAN

73 YEARS BOLD

Ellery McGowan has won multiple world championships in open-water, marathon and winter swimming. She is also head of swimming and water polo at Charterhouse school in Surrey, England.

We met Ellery at Guildford Lido one gloomy day in the early summer. After wandering around the grounds for a while, trying to find her, we realised she was already in the pool, doing lengths. Of course she was. Ellery is an open water swimming champion, after all. A bit of grey sky wasn't going to stop her from some al fresco exercise before our interview. This is a woman who swims through ice for kicks.

Meeting Ellery was exhilarating. She exuded strength – not just physically but mentally, too. Just a year before we met, her son, James, had died suddenly, aged 34. It was such an unimaginable loss, and we struggled (and failed) to find the right words when she told us, but she had the most remarkable attitude and, somehow, not even a trace of self-pity.

When it came to romantic love, though, she felt her strength was a hindrance, rather than a help, which seemed a terrible shame. She'd been separated for a decade and was ready to date but often found men couldn't cope with her. It was interesting for us to hear that her strength initially attracted men, but eventually became a point of conflict, as it was a suspicion we already felt for ourselves. We had both been told more than once that we might be 'too much' for a man.

Ellery didn't fixate on this problem, though. And she was certainly not going to dilute herself to find love. Thank God. Like many of our interviewees, she was happy on her own. Much as a man would have been a great addition, she relished her independence, which she felt she'd lost during her marriage. She'd got her personality back after the separation, she told us. She wasn't prepared to lose it again, although she was definitely open to love.

We left her that day determined to own our own strength as much as Ellery owned hers. Her spirit and the force of her character was the making of her – and we loved her all the more for it.

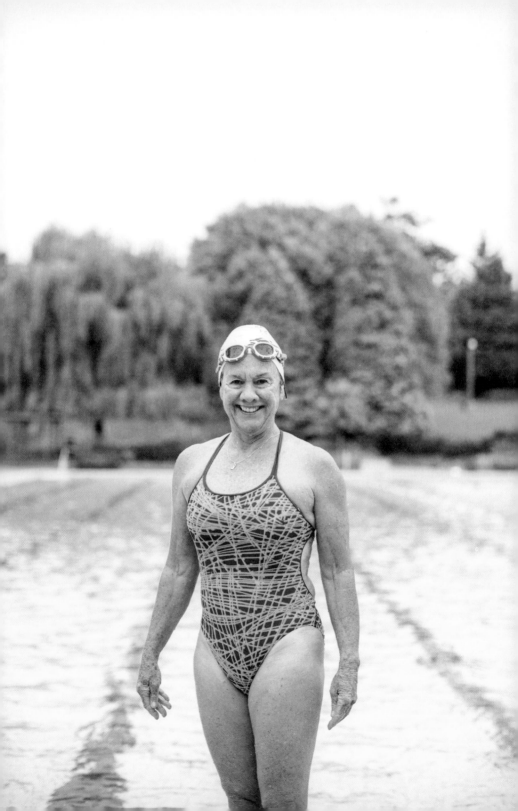

ELLERY MCGOWAN

"

I GREW UP ON A FARM IN TASMANIA, and from about the age of five, my twin sister and I used to go to the beach on our own. Nobody came with us, so we pretty much taught ourselves to swim. I think we were probably the first people in Tasmania to get nylon racing swimsuits, which made us very proud. After the 1956 Olympics, I kept a scrapbook with all the details of the athletes and swimmers involved. We even made lane ropes out of twine for the dam in our garden.

Perhaps it's that background that made me prefer open-water swimming to indoor competitions. It might be cold, but you feel so good afterwards. At the Winter Swimming World Championships in Russia last year, I cut my arms from swimming through ice, but I didn't even notice the blood until it was over. It's hard to explain how good the water makes you feel – you come out and you glow because all the heat has gone to your core. Even at the lido, you might look at the grey sky and find it uninspiring, but after a few kilometres, you always feel better.

Teaching is rewarding, too. I think participating and actually going out and doing something myself makes a difference to the pupils I teach. Rather than just saying 'Do this, do that,' I'm showing them by example. I have quite good self-motivation. As well as teaching, I do Pilates and spin classes every week. I do a core strength class every Thursday, followed by Gyrotonic after that. That's my indulgence because it keeps my joints mobile. I eat quite healthily, and I keep saying I am not going to drink every day of the week, but I generally always have a glass of red wine.

I've been separated now for about 10 years, so far I've left dating to serendipity, but I think I might have to try online dating. It does worry me, though. I need someone to vet people for me. I enjoy male company, but a lot of men are quite controlling, and I think they get envious of strong women. It might be what attracts

"I've been separated now for about 10 years, & I've left dating to serendipity, but think I might have to try online dating."

them in the first place, but then they seem to struggle with it. I've always been an independent person. When my marriage broke up, I found I got my personality back again. I was me and I wasn't answering to somebody all the time.

I think about death a lot more since my son James died unexpectedly last year, aged 34. I'm not afraid of it at all because I believe in the afterlife, but some days I think, 'I wouldn't like to die just yet.' But if my number's up, my number's up. I have no regrets. James packed so much into his life – and I think I do, too. He and I were very similar. It's made me even more aware that it's important not to put things off. I still have a lot of living to do. Antarctica is still on my list for a swim, and I've already signed up to swim from Robben Island to Cape Town, next year.

My life motto? Look for challenges and live in the moment.

"IF EITHER OF US
ISN'T HAPPY WITH
SOMETHING, WE
DON'T STORE IT –
WE TALK ABOUT IT."

EDDY DIGET, 74

"SEX ISN'T THERE
SIMPLY FOR SEX;
IT'S THERE FOR
MAINTAINING BONDS
& INTIMACY."

BRUCE FOGLE, 73

SUE PLUMTREE

74 YEARS BOLD

Sue Plumtree is a life coach and author. She also runs a Life Enhancing Group for the University of the Third Age. She lives in London, England.

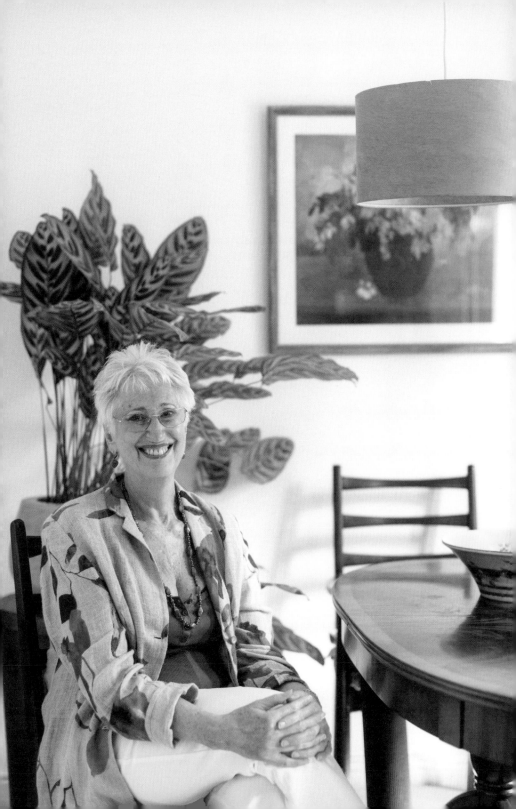

SUE PLUMTREE

I GOT MARRIED VERY YOUNG, aged 20, and stayed in that marriage for 37 very unhappy years. My parents had enjoyed a wonderful relationship, and I desperately wanted the same for myself. Unfortunately, that was miles away from the reality with my husband. From the moment I first laid eyes on him, I was thinking about how I could change him, but I was very insecure, so I decided to see if I could make him fall in love with me. I succeeded but, of course, he wasn't the man I had imagined him to be. As a result, I was disappointed, and I made that very clear. I was controlling and manipulative.

Finally, when the pain of staying was worse than the fear of the unknown, I knew I had to leave. I was 60 at the time. Up until I left, I blamed him for my unhappiness – everything he had said, everything he had done or not done. It wasn't until a few years later that I suddenly realised I wasn't the innocent bystander I liked to believe I was. That insight was intensely painful and forced me to change the way I saw myself. When you blame someone else, you make yourself a victim, helpless to change anything. But when you take responsibility for your own part of your relationship, there is something you can do about it.

The truth is that many people in later life can't bear the idea that they have wasted their lives, so they carry on regardless. I was fortunate. I went on to build a loving and fulfilling life for myself. I started attracting caring, supportive and open-hearted friendships and doing work I'm passionate about.

I believe you can find out almost immediately if somebody is right for you, but you first need to know yourself. We do have the answers, but they tend to be covered up with layers and layers of crap – limiting beliefs, mixed messages from our parents, the education system, society, the media and so on – all of which we need to unlearn. It was by sheer accident that I discovered I had a deep belief that

I didn't deserve to be loved. I was shocked, but the evidence of my belief was there – an unhappy marriage and superficial friendships.

Meeting Paul two years ago was a complete surprise as, by then, I didn't feel there was anything missing in my life. I was happy and doing all kinds of new things. I love cooking, so I'd decided to start a new U3A [University of the Third Age] group called Come Lunch with Me. As it turned out, Paul was one of the first people to join the group, and that's how we met. Our early conversations just flowed. I recognised in him a very kind man, not only because of how he treats me but also how he talks about and treats other people.

People don't imagine older generations having sex, but we can't keep our hands off each other. Good sex starts outside of the bedroom with trust, friendship and emotional intimacy. We had to think about things like STDs, which are rising in our age group, and so we both went to the doctors to get checked. Also, I was worried about being seen naked, especially because I have scoliosis. But this is the amazing thing: he looks at me and sees a beautiful woman. It took a while for me to accept that but, in the end, I decided to believe him – a gift to myself and to him. Besides, when I look at him, I see a hunk! He too found it hard to believe at first, but now he takes it in his stride.

At 74 I feel great and I know I look good, too. That's to do with having good genes, but I'm not afraid of wrinkles. I've earned them! There's nothing I'd change – even the painful times. They were the times that made me the woman I am today, and it's the same with Paul. Sometimes we wonder why we had to wait so long to find each other, but the answer is it took all our experiences to be ready for each other.

I believe in the ripple effect. It takes so little to lift other people up. But we need to learn to open our hearts to ourselves first before we can open them to others.

HEALTH

&

FITNESS

LET'S BE HONEST: AGE IS NOT KIND TO THE BODY.

As much as Bolder has shown us that love is possible at any age, success can come at 90 and old age is no barrier to happiness, health is the anomaly. Like it or not, we're all heading towards the same final destination. As we get closer to the end, things stop working. Our bodies break down more and we get considerably slower, both physically and mentally. We have no control over that. It would be easy for the conversation to stop there. In fact, let's all give up and have a cup of tea – a glass of wine actually, or a bottle. Because, frankly, what's the point?

Here's the thing, though. We do have control. Sorry to break it to you. But we can choose whether, aged 35, we're going to drink two bottles of wine a night or whether to call it a day after two glasses. We can decide whether to start smoking or whether we should quit. We are in control of going to the gym or going for a burger. Society and our ageing bodies do not dictate that we open that bag of Doritos and watch Netflix. Again. They'd much rather you didn't, actually.

When we started Bolder, we of the binge-drinking generation were looking for excuses and loopholes. We wanted to find 90-year-old smokers or 101-year-olds who'd been drinking a bottle a day for the last 70 years. To

our dismay, they have been few and far between. Gordon McVie, a vivacious oncologist, told us 'everything is fine in moderation.' He took up Pilates aged 69, got a personal trainer at 71 and relishes his two glasses of red wine every night. Pierre Gruneberg, our 88-year-old swimming instructor, told us, as he bounced down the steps into the Mediterranean in his Speedos, that he swam a mile every single day. Artist Michael Sandle, at 78, swore by the trampoline he kept in the garden.

Soon enough, a pattern emerged. Most of the people we interviewed took care of themselves. Physically, mentally – often both. They didn't take their health for granted and they were aware of the need for regular maintenance. They may occasionally have mentioned their good genes, but regardless, they were taking control of their bodies and they were proactively staying fit. While we didn't find the excuses we were secretly looking for, we found their attitude and energy reassuring. Although we're all going to fall off the wagon sometimes – and yes, we might as well finish the Doritos now that we've started – our interviewees have put us back in the driving seat where our health and fitness are concerned. Now we just need to find our keys.

PIERRE GRUNEBERG

88 YEARS BOLD

As well as being a qualified physiotherapist and Courchevel's oldest ski instructor, Pierre Gruneberg is also a swimming instructor at the Four Seasons Grand-Hôtel Cap-Ferrat, in France, where he has taught the likes of Tina Turner, Paul McCartney and Robin Williams how to perfect their front crawl.

Pierre has worked at the Four Seasons Grand-Hôtel Cap-Ferrat since he was a teenager – and as we rolled up to this five-star palace in our humble hire car (rental car), we started to understand why he'd stayed put for 66 years. Pierre greeted us in a huge Mexican hat (his trademark attire) and proceeded to give us, his 'two beautiful ladies', an entire afternoon of his time.

Pierre ordered his own off-menu healthy lunch – the 'Salade de Pierre' as he called it – while we both got stuck into something far less virtuous, inevitably with fries. Carrot batons were proffered in our direction, enthusiastically, throughout the meal by way of redemption as he told us about his unusual teaching method, which had led to his reputation as the 'salad bowl teacher.'

After lunch he changed into his Speedos and led us down to the sea, where he took his own mile-long swim every morning. As he posed for photos on the steps down into the water, he'd fling an arm out to point us in the direction of his beloved lighthouse, or he'd hang off the stairs, hand on hip, beaming into the camera. This was his happy place, no doubt about it.

Everyone we've met through Bolder has some secret, some passion, some attitude that keeps them young. For Pierre, it was being physically active. The years just fell away when he was in the water. Meeting him showed us we were way off the mark when it came to our assumptions about exercise in later life. While we'd presumed we'd be capable of little more than a light stretch or a gentle stroll in our 80s, here was an 88-year-old who did more exercise in a day than we did in a week. Seeing that first-hand reframed our skewed mindset. Perhaps we wouldn't have to take up golf, after all.

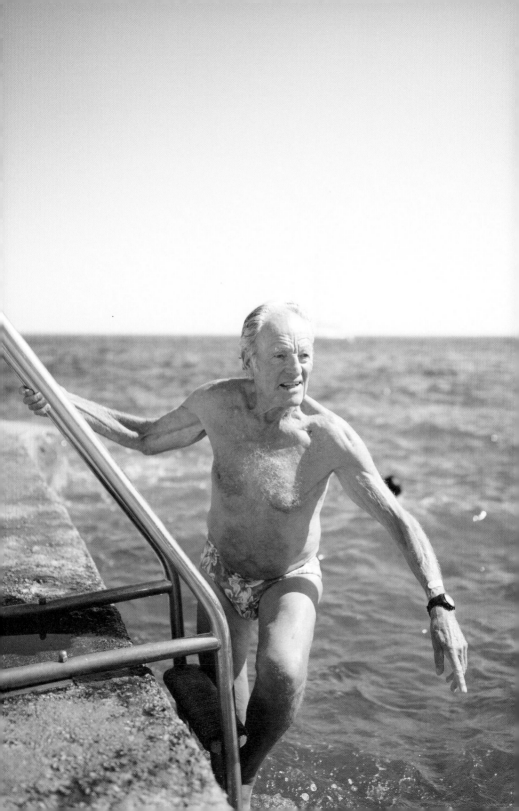

PIERRE GRUNEBERG

I'VE BEEN WORKING AS A SWIMMING INSTRUCTOR at this hotel for the past 66 years. For me, it's the best retirement home in the world! It was totally different back when I started; there was just a small snack bar and 99 per cent of the clientele were French – they used to come from the nearby villas. Now, of course, the local crowd all have their own swimming pools and the clientele is more international.

I am best known for being the 'salad bowl teacher.' The reason people can't swim is mostly about breathing. Once you learn how to breathe correctly, you know how to swim. My method is easy. I use a salad bowl filled with water and, for one hour, I teach my students how to breathe without even getting into the pool. I used to give up to 40 lessons a day, but now it's more like two or three. People come here to lie on chairs and eat more than to swim.

I have my bathing suit here in Cap-Ferrat, my tie in Paris and my skis in Courchevel – I split my time between the three. After I became a ski instructor, I decide to study physiotherapy in Paris. I thought it would be a good idea in case I broke a bone or injured myself while skiing. As it turned out, I was a very good student because I found it terribly interesting. I even ended up being the physio for the French Olympic team in Melbourne back in 1956.

My mother gave me some of my energy – after all, she is the one who helped us survive. We were born in Germany, but she moved the family to France in 1933 as we were Jewish. My father had just bought a new house and was more of an optimist, so he decided to stay but eventually joined us when it became more dangerous. All of the family members who remained in Germany ended up at Auschwitz. It was a very dark period. Although I've had difficult times because of the war, I've largely been very happy, particularly in love.

I've been married twice, and I met both my wives when I taught them how to swim.

"I have my bathing suit here in Cap-Ferrat, my tie in Paris & my skis in Courchevel."

My first wife, a well-known French classical actress, passed away in 1991 after 30 years of happy marriage. I was a widower for 10 years, and then I met my second wife while I was teaching in England on a promotion for the hotel. We dated for ten years and then got married when I was 80. She is 20 years younger than me, but age does not exist for us. We are just totally in love, which is the only secret to a happy marriage. Love is enough. It balances your life.

I am blessed to still be able to do everything I enjoy. When Four Seasons took over the hotel two years ago, I thought they might get rid of me, and I would have understood perfectly. But they saw that I was something of a legend here, so here I am. I do my best to keep fit. Every morning, I swim in the sea to the lighthouse and back [about a mile], and then I start working around 11 a.m. I don't drink, I never have, and I always eat my special 'Salade de Pierre,' which is packed with healthy ingredients. I don't eat meat at all anymore.

I really love people; I suppose I am interested in life. When I take the underground (subway), I want to know the story of everyone sitting in my carriage! I find myself wanting to ask questions.

What have I learnt? Be tolerant and don't judge people too quickly.

KEN
PARDEY

74 YEARS BOLD

Ken Pardey is a triathlete. He retired aged 55, after successful careers in both printing and property development, and lives on the Isle of Wight off the south coast of England.

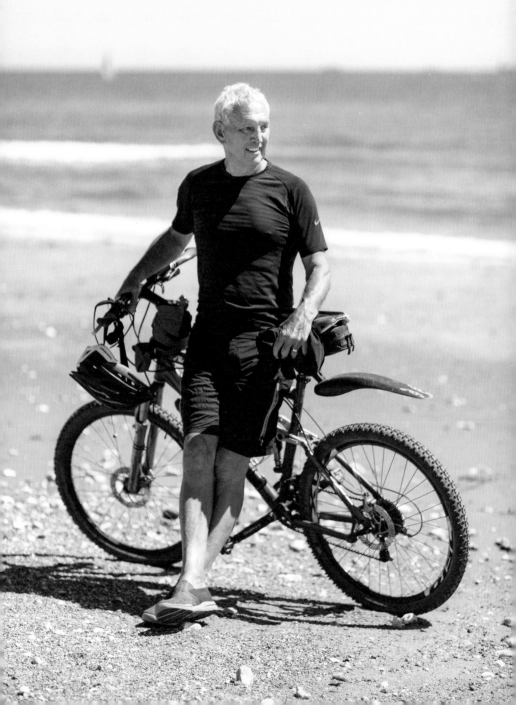

KEN PARDY

I HAD A REALLY CHARMED CHILDHOOD on the Isle of Wight. My parents were quite poor, but they brought us up fantastically. My father was a milkman and my mother used to clean the bank, so they both left the house at five in the morning. They used to tell us that we could do better, so I think I was always ambitious. As it turned out, I was able to retire at 55. I've been really lucky, but somebody once told me that luck is when fate and planning come together, and I think that is probably true.

Running a business is very simple; it's mostly common sense. You have to find good people, treat them properly and make sure the numbers are right. That's about it. I had so much fun through my career and met so many inspirational people along the way. I think team sports might have helped me to succeed. I played a lot of rugby when I was younger; you learn to be a team player because suddenly you have 14 friends wherever you go.

Every lunchtime at work, I'd take my team out for a run. I remember thinking, 'I hope I'm going to be doing this when I'm 45.' That number has been going up ever since. As long as I can still do it and it's not dangerous, why not? My daughter encouraged me to do the triathlon when I was 70, and I do plenty more besides. I go off-road biking at least once a week, and I've got canoes down on the beach, which I use quite a lot.

I remember when my parents retired, they didn't really do anything anymore. They seemed like proper old people. I think we're lucky that today it's more acceptable for people my age to do silly things. I learnt to horse ride when I was 70. Two friends and I decided things were getting a bit boring, so we decided to learn something new. Living on the Isle of Wight makes it very easy to be outdoorsy like that.

I met my wife Linda at school, and we are still together, although if you take into

"As long as I can still do it & it's not dangerous, why not?"

account all the time I was away with work, we've not actually been married that long! We have a great partnership and always have. I was lucky that she was always able to manage our home life and the children while I was away. Of course, it's never brilliant all the time. Sometimes it's horrible, sometimes it's fantastic and mostly it's alright.

Having children changed me a lot and continues to change me even today, as I now have grandchildren who keep me active. We'll go swimming, get the canoes out and have fun together. I always find them great for my mood – they keep me perky. I still don't feel like a grown-up myself, though. And more to the point, I don't want to. I've had fun all my life and it's continuing. In my low moments, I think I might not have long left. I think everybody fears death – I can't imagine not being here because I am having such a good time. But in general, I am hugely positive. Life is there to be lived, and you meet so many interesting people along the way.

What appalls me is when I meet people and I know all about them by the end of the meeting, but they know nothing about me. Lots of people forget to ask questions. That's a good lesson for life. Ask questions.

JIMMY
WICKERS

78 YEARS BOLD

Dr Wickremesinghe, known as 'Jimmy Wickers'
to his patients, qualified in medicine in Sri Lanka,
before continuing his training in the UK. He
currently works as a GP at his practice in Stockwell,
and up until 2006, also worked as a breast cancer
surgeon and an endoscopist.

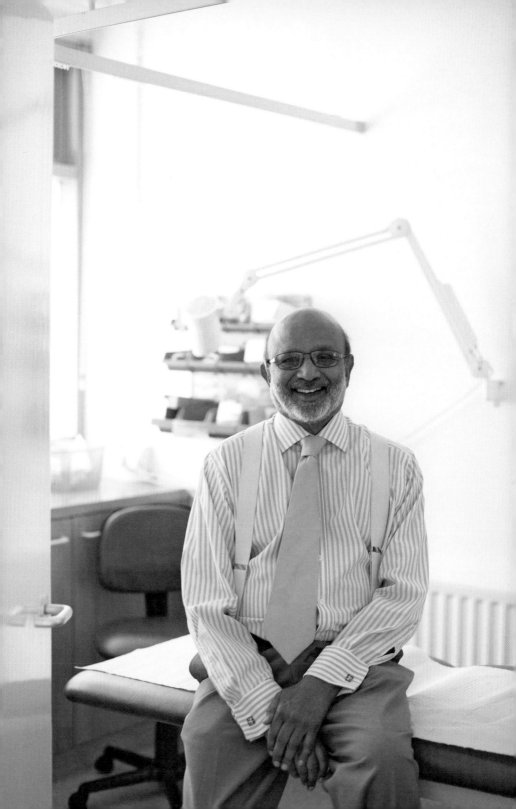

JIMMY WICKERS

MEDICINE HAS ALWAYS BEEN IN MY BLOOD; the majority of my family members are in the medical profession and my dad was awarded an OBE and CMG by the Queen in the 50s for his contribution to eradicating malaria in Sri Lanka, where we grew up. I moved to the UK once I'd qualified as a doctor. It wasn't a culture shock; as a British colony I feel we were bought up to be more English than the English in a way!

I've been with the NHS for over 50 years and I have seen families grow, relatives pass and new babies being born which creates a special bond as a doctor. As a cancer surgeon; I didn't have that type of long-term bond with my patients, although from a purely technical and medical perspective that was perhaps when I felt most inspired by my work.

I have a brother who is a cardiologist in Australia and if I had my time again, I think I would live over there; the work balance is much better and it's more conducive to a healthy lifestyle. Having said that, I do believe that life has a path and things tend to work out and settle as they should, so I tend to try and avoid regrets when I can. It's a waste of valuable energy. I was also invited to work over in America but I'm pleased I didn't go. The medical system there is very fractured and it's more of a commercial proposition. I work in quite a deprived area and I think it's important that patients get the treatment required irrespective of their ability to pay.

I know it sounds strange for a doctor but I'm a bit lazy when it comes to exercise and find it hard to stick to a regime. I like swimming but I don't like the pools in England, the water is too cold – so I just do a bit of walking and sometimes play tennis. I am blessed that every day I come back to a home-cooked meal from my wife Kath. She eats quite healthily so as a result I do too. I probably drink a bit too much; a couple of glasses of wine every evening, and the occasional gin and tonic, but I gave up smoking about 15 years ago. I was a heavy smoker, but I only started in my 30s. I used to bring duty-free cigarettes back from my travels for my friends then eventually I started myself!

"Being a doctor has taught me that you never know what people are going through behind closed doors. Always be kind."

I haven't really noticed ageism. We don't go by chronological age in my profession; biological age is more important. There are 60 year olds who are quite ill, while there are 90 year olds who are very fit, playing golf and living the life of Riley. As far as my work goes, patients tend to associate age with experience – at least that's my impression, so in practice it can even be a positive thing. One thing I do notice is loneliness. I have a lot of patients in their 80s or 90s living isolated in tower blocks, lots of them with no family or with children who can't be bothered to visit. This is a growing problem in England. There is no community cohesion. In Asian culture, older people are more respected and integrated into everyday family life. I think we can learn from this in the Western world.

The most important lesson I've learnt is to act with honesty, integrity and fairness with everyone you meet in life. Being a doctor has taught me that you never know what people are going through behind closed doors. Always be kind. I also think family is key. I always encourage big get-togethers at our home. We are lucky to see our two children, Nick and Katy, a lot – now we're just waiting for some grandchildren! All our contemporaries have them and we are very envious.

My life motto? Health is wealth.

TUULA OLIN

78 YEARS BOLD

Tuula Olin is a competitive ice skater based in Porvoo, Finland.

We travelled to an ice rink on the outskirts of Helsinki to meet Tuula, our Finnish skating champion. She arrived full of warm welcomes and smiles – armed with glittering gloves she'd knitted to protect us from the chilly surrounds. We were won over before she'd even stepped onto the rink.

After disappearing to get changed, Tuula emerged theatrically in full competitive kit. She then swept onto the ice and proceeded to floor us with her graceful moves – all performed with a serene smile. We sat shivering in the bleachers, feeling stiff and static by comparison.

Afterwards, as we chatted in the café, a real sense of mischief emerged. Her eyes twinkled as she told us about her life. Listening back to the interview weeks later, we couldn't help but cringe at the number of times we'd asked her about the dangers of skating. We didn't go so far as to say, 'at your age,' but it was pretty obvious that we felt she was risking life and limb out there on the ice. Happily, she didn't indulge our fears. She spoke of vague plans to buy a helmet, but at 78 she still felt it was too soon.

One of her most memorable tips about fitness concerned balance, a very necessary skill out there on the ice. She recommended standing on one leg at every opportunity to keep the body in check. No gym required, not even a whole lot of effort. We were sold.

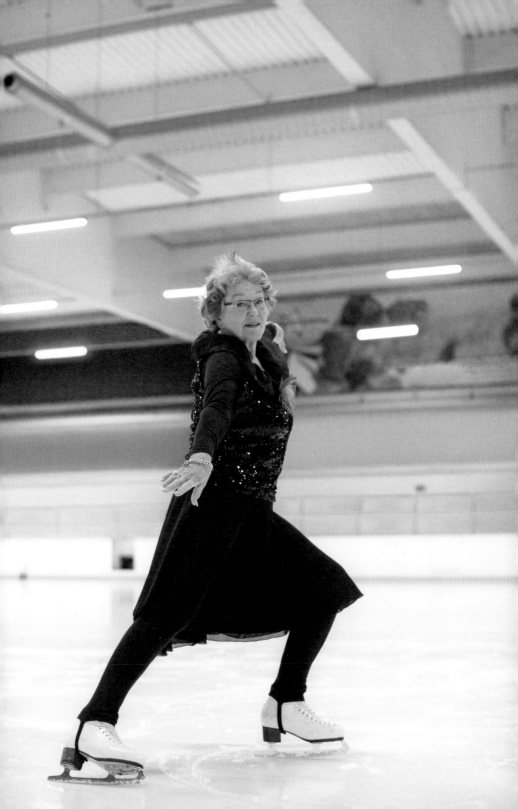

TUULA OLIN

I'VE SKATED MY WHOLE LIFE, but when my husband died back in 2009, I decided to start synchronised skating as a way to meet people. Skating really kept me going those first two years, which were quite heavy going. I made lots of new friends, and what's really nice is that many of them are 30 years or so younger than me.

More recently, I've started to skate competitively in the adult competitions organised by the International Skating Union. Last year, I came third in my age category for free skating, and the year before I came first in figure skating.

Of course, I fall quite frequently, but there is no problem with that. There is even special padding that you can wear. Perhaps when I am a little bit older, I'll buy a helmet. The worst part for me is getting back up again. I've always been quite fit, though, which helps. The most important thing in skating is balance: even while I am cleaning my teeth, I try to stand on one leg at a time as I look in the mirror. I also swim every morning of the summer in my little outdoor pool – it is freezing, but it's the best way to wake up.

Sitting still is the worst thing. I feel like there should be some sort of fitness programme on TV aimed at older people. Someone could come onto the screen while we are sitting having our morning coffee – and just encourage us to stand up and do 10 minutes of activity. There is a lot of talk about doing these sorts of things, but nobody ever seems to make it happen. It could save a huge amount of government money to keep people moving in their own homes.

As far as food is concerned, I am quite healthy. I have a greenhouse and a vegetable garden where I grow my own ingredients. I grow four types of berries, which I'll put on my porridge or in a smoothie. Of course, in Finland, you also get very good, fresh fish. If I am having some company or one of my daughters is coming

to visit, I love a glass of cold white wine, too. Pinot Grigio is my favourite, and we'll sit on the terrace and put the world to rights.

I recently reconnected with my first love. We met at school, but after he went into the army, we drifted apart. A few years ago, I found this stash of love letters from him and began to wonder if he was still alive. I tracked him down and sent him a text, and a couple of weeks later he called me. We speak on the phone a lot now – we'll talk about the old days, about our grandchildren or about politics. Now that we have Trump, there is not a day without drama.

I am really happy these days, but of course I still miss my husband. He was a good man and very clever. I probably got more from him than I could give back. But I did give him energy – and I made him good food! Little things make me happy now, like when I make a good dinner. Or when I give my friends presents that I've made for them.

My life motto? Do things for other people, not for yourself.

"Even while I am cleaning my teeth, I try to stand on one leg at a time as I look in the mirror."

STYLE

&

BEAUTY

IS IT REALLY ANY WONDER THAT WE SEE AGEING AS THE ENEMY WHEN IT COMES TO THE WAY WE LOOK?

The beauty industry counsels us to take a look in the mirror, check out that thinning hair, those new wrinkles around our eyes and the brown sun spots on our hands. Maybe you shouldn't have sunbathed for 10 days straight in Ibiza every year for the last decade after all. No bother, just buy this lovely little product and we'll help you fix it. Fail to adapt your wardrobe to your age, meanwhile, and you're embarrassing yourself. Just who do you think you are?

When we started Bolder, we believed that style and beauty were pretty much synonymous with youth. Why wouldn't we? 'Anti-ageing' is stamped all over the products in our make-up bags and the latest fashions are usually modelled by people barely out of their teens. But then we met a string of people who made us think twice. We came away from our interview with Barbara Hulanicki, the unbelievably cool founder of Biba, vowing to dress more like her. Zandra

Rhodes, meanwhile, made us ponder dying our pink hair. And Frances Dunscombe, sauntering around her house in jeans and louche blouse, was undeniably beautiful, wrinkles and all.

Style and beauty only get you so far, though, we now realise; you can wear all the best clothes and have not a wrinkle in sight, but if you aren't shining from within, how can you expect to radiate at all? What stood out more than anything for us was our interviewees' charm, confidence and passion for life – all of which combined to create a special sort of beauty that came from within. A cliché? Yes. A brilliant truth? Happily, yes.

As Roald Dahl famously put it in The Twits: 'A person who has good thoughts cannot ever be ugly ... if you have good thoughts, it will shine out of your face like sunbeams and you will always look lovely.' So perhaps we should be investing more in good thoughts, and less in good face creams.

SUE
KREITZMAN

Sue Kreitzman was a successful food writer for many years before making an unexpected transition into the arts world. Sue featured in the film *Fabulous Fashionistas*. She lives in London.

Before we started Bolder, Helen and I would often discuss the worrying link between age and style. We'd seen our own grandmothers with uniform grey, cropped hair wearing 50 shades of beige and sensible shoes and feared that was our fate too. Magazines suggested we should think twice before wearing leather jackets or leopard print post 40. The whole thing stressed us out. I wanted to try having shorter hair for a while, but friends told me I should just enjoy my 'last chance' at having it long. Helen, who can rock a mini like nobody else, panicked that she'd soon have to reign it in and embrace below the knee hemlines. We both spent our hard-earned cash on vitamin C facials, eye-poppingly expensive night creams, miracle mud masks – anything that promised to turn back the clock, basically. The message behind these costly cures and rescue remedies was that we were decaying and that urgent action needed to be taken. The future was bleak.

Thankfully, Sue Kreitzman set us back on the right path. She was dressed head-to-toe in vivid colour when we met. Her flat on a housing estate in East London was absolutely crammed full of her bright tribal artworks, no surface left untouched. As she said, there was barely any room left to cook in her kitchen, not that she cared.

When we got onto the subject of plastic surgery or turning back the clock, Sue positively roared her reply, 'Just be who you are for God's sake!'. Whether you agree or not, the message is a strong one. Of all the people we've interviewed, it is perhaps Sue who was most passionate about the fact that life is a gift and ageing is a privilege. Time travel, she called it.

After we met Sue, we ditched the magazine advice and the prescribed uniforms for our age. Why would we listen to anyone when it came to what we 'should' wear? Why on earth were we believing what we read as though we had no free will? We might still occasionally wear beige, but our leopard print isn't going anywhere.

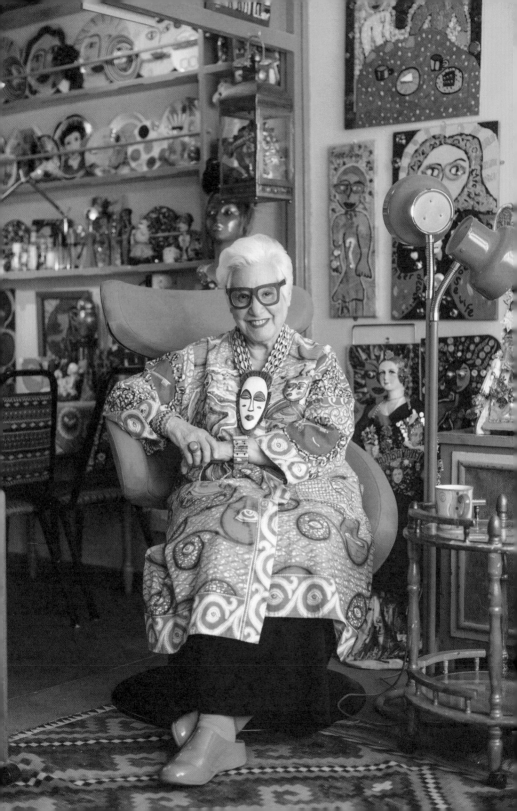

SUE KREITZMAN

AGEING IS A BLESSING, OF COURSE IT IS; what's the alternative? We're so lucky to be alive – it's time travel! There is an old lady revolution going on right now and we're becoming much more visible. People are living longer and living better. A lot of advertisers are using older women and the silver pound phenomenon is helping to change attitudes. I feel I'm a pioneer as I'm very vocal and do a lot of public speaking on ageism. I'm also very active on social media.

I honestly didn't register that I was an old lady until I was in *Fabulous Fashionistas* and realised it was a film about old people. I loved being a part of it. We didn't know the power it was going to have – but it went viral, and it's given me a cult following. I was also one of the first people to feature on Ari Seth Cohen's blog Advanced Style, which was later made into a film.

I grew up in Washington Heights, Manhattan. My father was a photographer, but my mother was not in the slightest bit creative. She was also an incredibly bad cook – she murdered food. I had no idea it was such a delight until later. I taught myself a lot and made a successful career of it. My parents died before I went into cooking and neither of them have seen my art, but sometimes I think it's just as well. Lots of people don't understand it.

I have no regrets: everything that's happened, good and bad, has brought me to this point, and I have an amazing life. I met my husband in high school when I was 15 and he was 16. He works in Cambridge and I work in London, so we have separate lives during the week and then spend weekends together and go to New York a few times a year. That's the secret to our happy marriage. He's a scientist, but he is very supportive of my art, as is my son, who lives around the corner from me in East London.

My arts career took me entirely by surprise. Perhaps it was a psychotic break! I was editing my 27th cookbook in my study and my hand picked up a marker and drew a mermaid on a piece of paper. I looked at the mermaid and she looked at me, and I suddenly became insanely obsessed with drawing. I turned into a crazy woman. I was drawing day and night. My agent thought I'd lost my mind. My family

"I don't believe in Botox or plastic surgery. Just be who you are for God's sake – accept that this is what time does to us."

thought I was mad. Lots of my friends couldn't understand. I kept it a secret for a long time – I guess I was a closet artist.

I've never tried to make my art a commercial thing, but things just seem to keep happening to me – life just keeps falling into my lap. Selfridges [department store] gave me the biggest window a while back and let me do whatever I wanted. It made history; people flew in from other countries to see it. Whenever I was there, I would get mobbed – it was the most wonderful feeling of celebrity. It was once in a lifetime. The creative director of Selfridges told me it was the best window in their history. I got two book offers after that.

I get to make things every day of my life. I exhibit all over the world. I'm in demand as an artist. I consider myself a work of art and every morning, I don't get dressed, I curate myself. I can't take my art with me when I leave the house, so I wrap myself in it. I'm a walking collage. Instead of being locked up in a lunatic bin, I've become world famous for being a weird old lady – it's the best thing that ever happened to me!

I believe we are all ageless, but we're not immortal. You have to make every day count. I try my best to take care of myself, but it's also a matter of genes. I don't believe in Botox or plastic surgery. Just be who you are for God's sake – accept that this is what time does to us.

My life motto? Don't wear beige; it might kill you!

MARION FOALE

80 YEARS BOLD

Marion Foale is a British fashion designer who rose to fame in the 1960s as one half of the brand Foale and Tuffin. Today, she runs her own knitwear label and collaborates with other fashion brands.

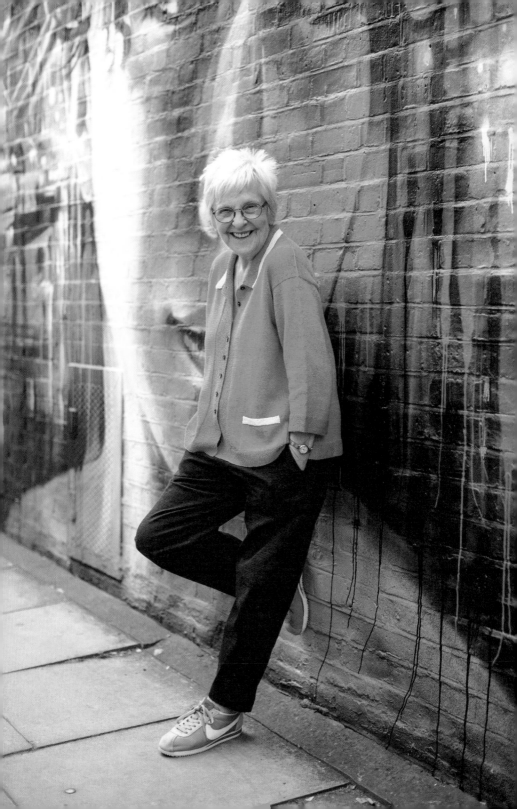

MARION FOALE

SALLY AND I SET UP FOALE AND TUFFIN from our bedsit, just before we finished at the Royal College of Art. Mary Quant's husband had come to give a talk and afterwards, we just thought, 'We could do that.' As soon as *Vogue* came along and photographed one of our pieces, that was it. We never even thought about it not working out – we were young and just keen to do our own thing.

It was great running a business with someone else. It helped to have somebody to bat the ball with – and the fact that we were two women made it even more fun. In those days, no females went to buy fabric wholesale – it was men in grey suits who did that. People thought it was hilarious. We'd have meetings in the London showroom, where someone would sit there for a bit and then say, 'I'm waiting for the man who runs this.' I wouldn't say we were offended, we just knew that women were taking over.

I was totally driven right from the start, I think because my father was very controlling. I had wanted to be an architect originally, but he told me he didn't want me to have further education because I was a girl. I wanted to show them I could do anything that a man could do. My attitude was very much, 'I'll show you.' Although even after I was a success, my parents never spoke to me about my work.

I was quite old when I had my children. It wasn't that I felt pressured to have them – I have never cared about society's opinions at all – I just didn't want to miss out on anything. Women certainly don't have to be mothers, but if you do have children, it's the hardest thing you'll ever do. Going to work felt like a doddle after that. Motherhood has been my biggest achievement.

After I had children, I decided I couldn't go back to doing what I used to do, so I decided to teach myself to knit. I love tailoring, so I thought I could combine the two. Thankfully, people loved it. I wouldn't call my brand 'fashion' – it's clothing. To me, clothes are for wearing – for doing the washing up in and going to the supermarket. High fashion doesn't really move me.

"To me, clothes are for wearing – for doing the washing up in & going to the supermarket. High fashion doesn't really move me."

I don't want to ever stop working. The idea of it terrifies me. I never worked for the purpose of getting lots of money. If you're happy, that's gold dust. The trouble is, lots of people don't enjoy their jobs. It's a real gift doing something with your life that you love every day. And I don't think you have to be creative to have that. My son finds his accountancy enjoyable.

My husband and I were together for 21 years. We had a lovely thatched longhouse in the countryside and grew organic vegetables. It sounds lovely, but there was nothing organic about our marriage. I was much happier after we divorced. I wouldn't date again. Companionship, yes, but nobody is coming into my house. I am enjoying my second life too much.

I've just lost the second of my best friends, so thinking about death is forced upon me at the moment. It just makes me think you should do everything you want to do now. Don't hang about. The biggest lesson I've learnt? Aim high. Don't just go for a little step, go for a big leap and you'll be surprised at what you can achieve.

My life motto? Cram it all in, do as much as you can, in every aspect of your life.

NATALIE GIBSON

80 YEARS BOLD

Natalie Gibson is a fashion designer and fashion print teacher at Central Saint Martins college in London.

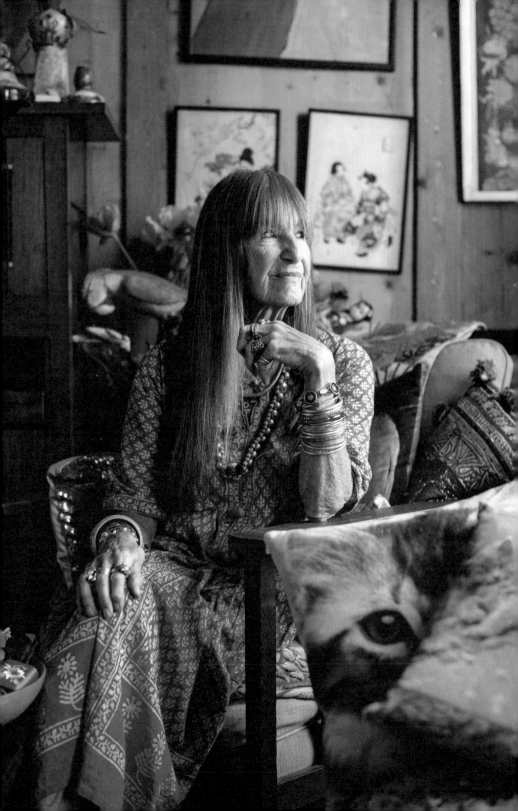

NATALIE GIBSON

WHEN I WAS ABOUT SEVEN, I was shipped to my grandparents' farm in Scotland because of the war. I went straight from there to boarding school in Surrey where nobody could understand me. It was a huge culture shock – I thought it was a bad dream and that I'd wake up. Eventually, I loved it – though I decided to go to Chelsea Arts School instead of staying on to do my A levels. Our teacher there was called Frieda Halo, believe it or not. I could already paint, so I decided to learn something else – that's how I ended up doing textiles.

Today, I teach at Central Saint Martins and have been here since the 1960s. There's no reason to retire when you enjoy your job. I think if my younger self could see me now, she'd be surprised that I could get work doing things I actually liked. I never had any grand plans really – but you didn't have to pay extravagant amounts to study back then, so you didn't need to think things through so carefully. Lots of my students today are so stressed about what they are going to do. I have noticed them getting more and more worried as the years go by.

I had two children, but I was determined that it wouldn't change my life. I didn't stop working – I just took them everywhere with me. They used to sleep on the print table at the college. Their father ended up going off with a gorgeous student and I was heartbroken. I am so pleased now that he did as, otherwise, I wouldn't have met my current husband Jon – we got married in 1979.

We've lived in Bermondsey for years. It has transformed: I used to walk around and never see a soul. I'd quite like to have lived somewhere a bit warmer and lighter – that is perhaps my only regret. Especially as I love colour. But I love London. There is so much going on. I've also got a place in the countryside, which I bought on the earnings I made printing for Twiggy. You have to go through two fields to get to it; it's in the middle of nowhere and really peaceful.

"Some people even apologise to me if they are all in beige or something."

Life has had so many good moments – but I am really enjoying it at the moment. As long as I am fit, I am happy. Health is so important. I probably drink too much, but I don't smoke and I go to Pilates once a week. I walk a lot – up and down the stairs on the Tube – and getting to and from work. I think the energy of the people I teach is good for me, too – it rubs off on me. And I think travel keeps me young. I run a workshop in India every year, and I also teach a lot over in China. I actually just got back from France where I was staying with a friend I have known since I was seven. Those old friendships are hugely important.

I get a lot of comments on my appearance. Usually nice ones – it cheers me up in the morning. Some people even apologise to me if they are all in beige or something. Colour and print inspire me rather than fashion. I don't 'follow' fashion at all. If you look down the carriage of the Tube, most people are wearing black or beige. It's quite rare to see colour. Perhaps it makes people feel safe. I started dying my hair when I was quite young – my students often get me colours. I just morph from pink to purple really.

I know it's boring but the most important thing I've learnt is to be kind. Just be nice to people.

ZANDRA RHODES

79 YEARS BOLD

Zandra Rhodes is a British fashion designer whose eponymous brand turns 50 this year. She is also the founder of London's Fashion Textile Museum.

D+H For some reason, both of us decided to dress entirely in black when we met Zandra Rhodes; perhaps we'd subconsciously been afraid to compete with her hot pink hair and unconventional wardrobe? As it turned out, that's exactly the sort of self-conscious, apologetic attitude that makes Zandra despair.

She made quite the impression on us both, not least because she so obviously backed herself. Zandra owned her looks, her style, her opinions in a way that women so often don't. There was no self-doubt, no self-loathing – she was totally self-possessed and yet, there was no ego, no arrogance. She was really and truly an individual, from her quirky penthouse apartment at the top of the Fashion & Textile Museum to her 97-year-old boyfriend. Zandra resolutely refused to follow the crowd. As a result, the crowd wanted to follow her.

She despaired of plastic surgery and our seemingly collective desire to turn back the clock. Her beauty regime was dreamily low maintenance; she has better things to do, other things to worry about. Unsurprisingly, she was a pro in front of the camera – she just radiated confidence. Being 79 never looked so good.

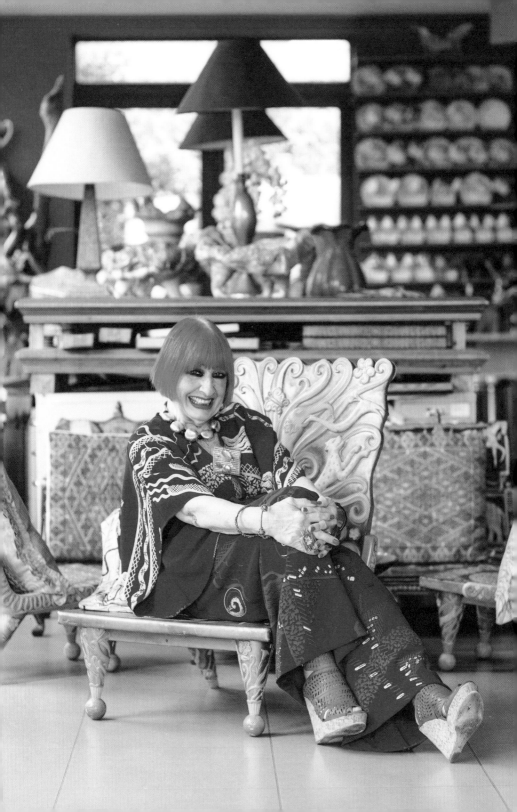

ZANDRA RHODES

MY MOTHER TAUGHT DRESSMAKING IN AN ART COLLEGE, and I used to love wearing her pretty little dresses on a Sunday to visit my granny. The local kids would laugh at me and throw stones, so I had to run through the park, but I wouldn't allow anyone to stop me wearing what I wanted. I am very lucky that I have always been pretty thick-skinned. I once got a letter from a girl who was at school with me apologising for always laughing at me on the school bus. I hadn't even noticed! I seem to be immune to all that. If you care too much about other people's opinions, it can stop you from experimenting or trying new things.

I was a very boring, hard-working girl at school. I didn't particularly want to go out or rebel. I think that's the secret to my success to be honest. When I give lectures, I say, 'You can be anything you want to in life, but you have to work hard.' If you have a birthday party that clashes with a presentation – tough. If your alarm goes off at 6 a.m. and you don't feel like getting up – tough. I was lucky that I had a very hard-working mother, so I had her as a role model. To me, the only thing that doesn't let you down in life is your work. You can't rest on your laurels, though – it might seem like you've made it, but there are always peaks and troughs.

I was in my late-40s when I met my boyfriend, and I'd pretty much given up by then. I'd kill myself to get dates. Men can't cope with women who work most of the time, so I was lucky to meet a fellow workaholic by chance at a dinner party. He was very conservative – he couldn't believe my hair – but we were a good match, regardless. He's 97 now and we've been together for 30 years. The 18-year difference sounds a lot, but it's not that significant when you're past 40. We didn't have children, but to some extent I have children in my life as there are young kids around at work the whole time, along with friends' grandchildren who often visit.

Having good friends is enormously important. You have to be positive in life and they help with that. I like cooking, so I'll often have 10 or 15 people over for dinner here at the flat. When I am not in the UK, I have another home right on the beach

in Del Mar, California, where all the surfers are. I exercise more over there – I'll do a stretch class one morning and Pilates another morning, and a lot of walking. I ought to do more in London but there's never enough time. I don't drink or smoke, though – and most of my close friends don't either.

The only time I am really going to notice that I'm old is when there's nobody there to look after me. I think I'll go to Switzerland and just disappear. Do I want to rot somewhere? I don't know. I've seen what happens to other people. But in general, I don't think about death yet. I'm too busy. If you keep working at the rate I do, you don't even notice yourself getting old. It's funny – you just get there. And I am certainly not going to try to turn back the clock. I see lots of women who looked really fabulous at 40 suddenly deciding that they need fish lips and fillers. They don't look younger, they just turn into something else. I wouldn't touch plastic surgery. I don't even wash my make-up off at night. And if I am running late, I just put make-up on top of make-up.

One of the most important life lessons I've learnt is that there's no point having regrets. If you have regrets, you live in the past and don't move forward in other ways.

My life motto? Never give up. Live life to the best of your ability.

"I wouldn't touch plastic surgery. I don't even wash my make-up off at night."

WORK

&

CAREER

CAREER SUCCESS IS SOMETHING THAT MUST BE ACHIEVED BY A CERTAIN AGE, IS IT NOT?

At least, that's what we're taught. Do well at school, get to a good university and climb the career ladder. Before it's too late, before you burn out, before you're too tired or before you become obsolete thanks to the sheer number of years you've spent on this planet. Success has a deadline, and if you miss it, you have a fading future ahead of you, fool.

Since starting Bolder, we've realised how little logic lies in this way of thinking. Why – when you have built up more experience than anyone else – would you become less useful? It was clear to us that all of the people we interviewed for Bolder, without exception, would be an asset to the right company, the right office, the right work team. More to the point, they wanted to work; they wanted to show up.

Before we reach retirement age, the idea of giving up work might feel aspirational. A time when we can finally shake off the shackles and start living our real lives? Heaven! But isn't it a shame to wait until you're in your sixties

to start living? Our Bolder interviewees tended to think so. Most of them felt blessed to be doing a job they loved and had no intention of ever stopping.

'My work is my life; it's like breathing air,' the 71-year-old hotelier Madame Duckstein told us. The list goes on. Oncologist Gordon McVie cited terrifying statistics about the death rates of doctors and dentists the year after they retire. 'I have no intention of retiring anyway, because we haven't cured cancer yet,' he told us outside Guy's Hospital in London, before he dashed back to work.

Much of the time, the people we spoke to had found a job they were passionate about: to give it up would be a punishment, not a gift. The takeaway? Work can be enriching. Maybe success is simply making it your business to find and follow your passion. Realising that you've spent most of your life doing something you enjoy so much that you don't want to stop? That's the real gift.

PHILIP WOOD

77 YEARS BOLD

Philip Wood is one of the world's leading experts in financial law and has written 19 books on the subject. He lives in Surrey, England.

D+H We met Philip Wood in a huge corporate boardroom, a panorama of the grand London skyline visible behind him. We'd already had to go through security to get into the building, and, surrounded by immaculately suited and booted lawyers, we were somewhat out of our comfort zone. As we all sat down around the gleaming boardroom table, Philip immediately reassured us. As usual, our nerves were unfounded.

Later on, when he told us his philosophy on courageous decision making; we were both quick to challenge him. 'What if we make the wrong choices though?' we asked. He told us that there was no such thing; you simply pick a side and go with it. Be bold.

At various points in our lives, we have both been serially indecisive or unconvinced by certain life choices, big or small. Take that exciting job abroad or stick with what we know? Put that extra money aside or jump on a flight to the sun? Tinder, Bumble or real life? In Sylvia Plath's *The Bell Jar*, there's a paragraph where Esther, the protagonist, visualises a fig tree, imagining it as a tree of choices. Her worry is that if she takes too long to choose between all the juicy fat figs, they will wither and die and she'll be left with nothing. It's this kind of ruinous procrastination that Philip was warning us about. His idea that there was no such thing as a wrong choice appealed to us. Indecisiveness was the barrier to success. Everything else? Life experience. We've tried to take his advice and be bolder when it comes to making decisions ever since.

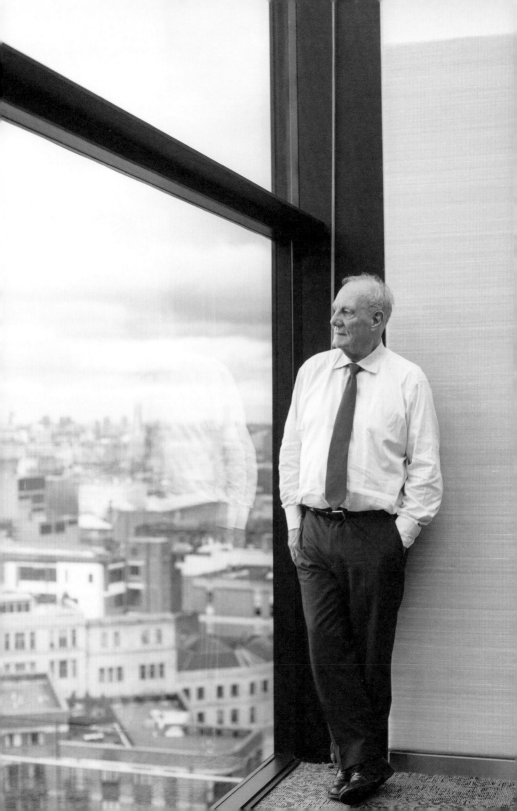

PHILIP WOOD

MOST JOBS ARE 95 PER CENT DULL, and a lot of mine involves commas and tedious administrative chatter. It doesn't matter, though, so long as you do something. When I see people performing tasks which they feel are futile and have no impact, I think, 'Don't worry,' because for us to do anything in the world we need this multiplicity of little efforts just to push the tide. The people I admire most are the ones who I think are conscious of more than just their own pleasure and feel a sort of duty to help in order to survive in the universe.

I was born in the middle of Central Africa, where my parents had emigrated in the 1930s. My early youth was spent in a place called Livingstone by the Victoria Falls, and I must say it was a charmed existence, although it was sinister in terms of insects, disease and the heat. I never developed any patriotism for Africa as we were foreigners there, so as a result I have always identified with the people of the world; that's not just a piece of waffle – it's true. I have always felt that tribalism is fine for football but not for important things. It's too dangerous. I ended up in a law firm which shared that view.

The one thing we all do have, which is divine, is love. Love is a time of ecstasy and real delirium, when you don't care whether you live or die. I still feel that. I met my wife on holiday in Marbella, and we have been married since the late 1970s. I do feel grateful for it. I have never felt disappointed or sad or melancholy because I have love. Family helps a lot, too – we had four children and I gloried in having them.

We live just outside a village called Shere near Guildford now. Our house is on a hill and enjoys beautiful views. I find Britain extremely reassuring and endlessly charming – all the seasons are just magical. I even like the rain! My wife designed our gardens from nothing, and she wants people to see them, so we open the house and grounds to the public. I suppose it keeps things interesting.

I've always liked running. I used to run from Waterloo [station] into the office and

back in the evening, and I still run four times a week. I have done a few marathons but the Paris marathon [which he ran at age 72] was a disaster – I was fit, but we got up to the Eiffel Tower and there were some young ladies cheering me on, so I broke into a sprint, showing off! I ran about 75 metres and pulled every muscle in my body! But I thought 'I've come here to finish the damn thing,' so I carried on. I walked the rest and I got the medal, so technically I did it, but it was so humiliating!

Obviously as you get older there are some things you don't do quite so well – running marathons being one of them. But I have always accepted the shape of life. I don't get sulky. That is not an effort; I think it's just the way I am. Getting older has never bothered me. I recently had a horrible operation and for various reasons the odds weren't great. I didn't feel frightened. I have never felt a terror at dying, but I have felt a terror at us all dying. It came to me like a thunderbolt – we may just all return to blind particles of nothing! That was a terrible realisation to me.

I don't have regrets. That doesn't mean that everything has gone well in my life, but I am philosophical – I just feel fortunate to be here. The worst thing for me would be just to exist. The world is so rich. There is so much you can do; it's hard to choose. But you have to choose – there are certain selections you have to make throughout life. One must be bold and courageous about them.

Often, people tend to follow the path they believe they have been given – even though it's not actually there. They could go off and do something else and realise different potentials. As people get older, they sometimes realise that the path was never real. It was merely an illusion.

When I got my CBE [Commander of the Most Excellent Order of the British Empire], I had to have a coat of arms drawn up. For that, I had to think about what my motto was, and I finally settled on 'Lux et Fortitudo,' which is Latin for 'Enlightenment and Courage.'

BARBARA
HULANICKI

82 YEARS BOLD

Polish-born Barbara Hulanicki rose to fame with
Biba, the fashion label she founded alongside her
husband Stephen Fitz-Simon in the 1960s. She now
resides in Miami, where she has found a second
career in interior design.

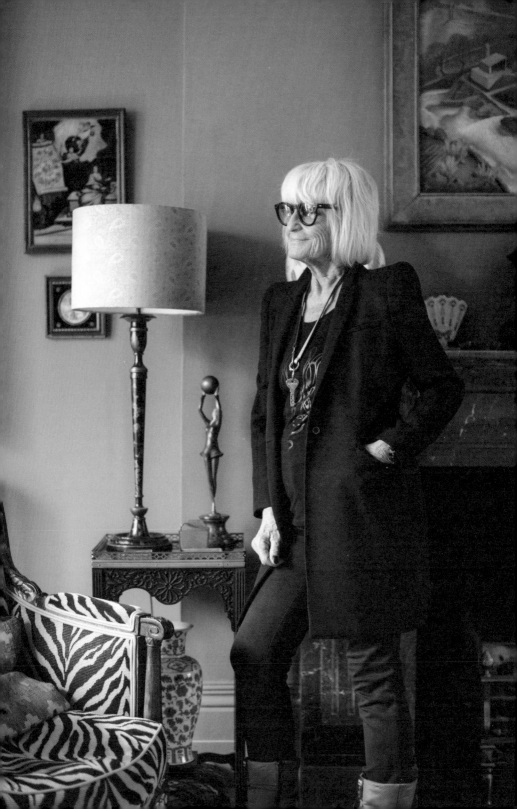

BARBARA HULANICKI

I WAS BROUGHT UP DURING THE WAR and had a happy childhood in Jerusalem, where my father was a diplomat. There were no toys or anything like that, you had to make things yourself or draw. That's probably why I ended up doing what I did. My parents were very creative, too, so it wasn't very rebellious of me to go to art school. I was exceptionally influenced by my father; he did all these paintings and illustrations, and he'd tell us stories about England. After he was killed [Barbara's father was assassinated by a paramilitary organisation in 1948], we moved over to the UK. It was a terrifying time.

In London, I went to art school and then found myself a studio that specialised in fashion illustration. I started making tea then worked my way up. Eventually, I was covering shows like Dior, Balenciaga, Gucci and Nina Ricci. I was 21 or 22 and was earning money, but I noticed there were no clothes to buy – people wore their mother's things. Felicity Green on *The Mirror* used to do a great fashion page and gave me my big break in 1964, asking me to design a low-cost dress, which she then featured in the paper. We got 17,000 orders! Fitz came back from the mailbox the next morning dragging a sack of post with him with a huge grin on his face. That was the start of Biba.

I met Fitz at a party, and we got on like a house on fire. We were together for 35 years – before his demise in 1997. We worked together, but we never crossed each other's paths. I believe in astrology – I am a Sagittarius and Fitz was a Pisces: it was a good match. Sagittarians are a pain in the arse: we get terribly depressed and then suddenly we're happy again. As far as dating goes, I'm done. I have huge friendships, though, especially in London. All my friends there are about 10 years younger than me, which is great. The English are tough to break, but once you're through, you're through. Americans are quite different. They are very positive.

We first came to Miami in 1989. It was amazing as there was nobody here – you'd walk along the beach and all these opportunities would just present themselves. Ronnie Wood had opened a club and wanted us to come and do the interior design.

"Keep plodding. Especially when you feel like nothing is happening. Suddenly it just clicks. Something you did six months ago reappears, even years later."

Then I met Chris Blackwell from Island Records; he'd bought 12 buildings which he wanted me to do up. That got my interior design stuff going. I love living here now – there's something going on every night. There's a fantastic gay scene and lots of creatives. I don't drink as I can't work well the next day and I find it depressing. I get invited to all these fashion parties and everyone is fucking drunk!

Exercise-wise I walk a lot and I go to Alexander Technique classes – it's terrific for aches and pains. There are so many health food places here, too, so it's easy to eat well, and the shopping is fabulous of course.

I won't ever stop working – I'd die of boredom. Before Fitz passed away, he said I should get back into illustration. At the time, I said 'No, I hate it.' But now I am doing more of it. Drawing is such a high. If you're depressed, you start drawing and you feel amazing.

The greatest lesson I've learnt in life? Keep plodding. Especially when you feel like nothing is happening. Suddenly it just clicks. Something you did six months ago reappears, even years later. You might not even appreciate it, as by then you're 10 paces ahead – but appreciate it you must.

"IF YOU'VE RETIRED, THE BEST THING YOU CAN DO IS GO BACK TO SCHOOL."

JÖRMUNDUR HANSEN, 79

"YOU HAVEN'T
FAILED AT ANYTHING
UNTIL YOU'VE
STOPPED TRYING."

JENNIFER MURRAY, 76

CLEO SYLVESTRE

74 YEARS BOLD

Cleo Sylvestre is a film, television and theatre actress.
She also performs the blues as Honey B Mama.
She lives in London, England.

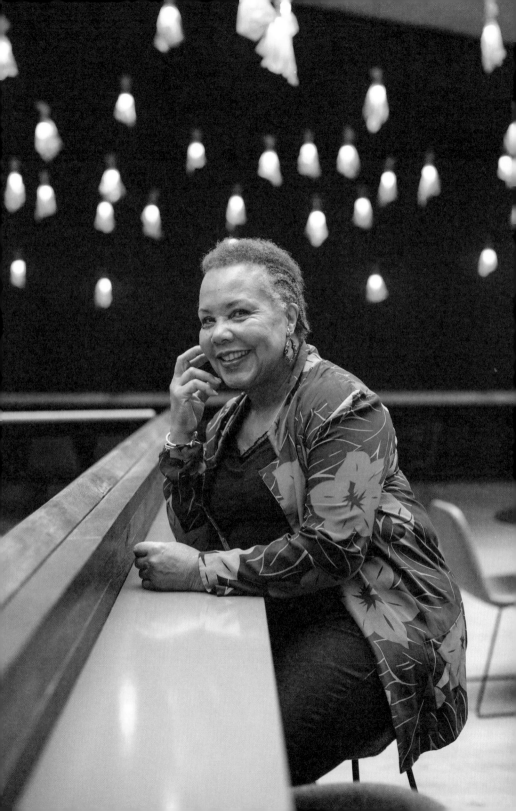

CLEO SYLVESTRE

"**AS FAR BACK AS I CAN REMEMBER I WANTED TO ACT.**
One of my godfathers was Constant Lambert, a conductor at Sadler's Wells Theatre, and I remember seeing various productions there. I did quite a bit of performing at school, but when I was leaving my head teacher told me there were no coloured actresses in Britain. She thought she was doing me a favour and what she said was actually true, but thankfully it just made me even more determined.

Casting is far more inclusive now. When I started off, you basically played nurses or prostitutes. That was the range that you had, although the colour thing was secondary to the class thing for me. Having been brought up in a council flat near Euston, I saw class as a bigger struggle. I felt like that was the issue that had to be addressed – and that once that struggle was tackled, everything else – sexism, racism – would be dealt with as well.

As far as my age goes, work seems to be OK. Middle age was actually hardest for me as it coincided with me having a family. I didn't have kids until my early 30s and then my husband died when I was 48. We had three children together, and they were my priority. It was important to try to remain optimistic for their sake. I was lucky that I had a close-knit group of friends around me, too. I never married again, but I haven't ruled it out. It's really difficult, though, because a lot of men my age are only interested in someone a lot younger.

The best thing about getting older is that I can say what I bloody well like. It's great. I was far more circumspect when I was younger. Now if I see something I don't like, I'll say so. Obviously, I won't be rude to people or try to upset them, but I am just far more honest in how I react to people and things. It's quite liberating.

Just before my 70th birthday I suddenly decided I would like to do something with my passion for blues music. I'd met The Rolling Stones years back and made a record with them before they were famous, but acting had been the main thing for me, so singing lay dormant. As I got older, I started to think I didn't want to be lying on my

"My head teacher told me there were no coloured actresses in Britain. She thought she was doing me a favour, as what she said was actually true, but thankfully it just made me even more determined."

death bed thinking, 'If only.' So I got up and sang at a party, and then the band invited me to come and sing with them. Honey B Mama developed out of that.

I feel sad now that you can walk along the street and nobody is looking up. Everybody is staring at their phones. People are disconnected from nature. Most inner-city children have no idea what it's like to hear birdsong or look up and see the stars – all they can relate to is this phone in front of them. My mum was brought up in rural Yorkshire, so when I was a kid she would take me out on the Green Line bus, which went out from London to the countryside. We'd go and collect elderflowers or blackberries. I think that appreciation of nature has stayed with me. I have my own little back garden in London, which is a haven. I get so much pleasure from it.

One of the most important things I've learnt over the years is to look at the simple things in life and appreciate the pleasure they give you.

Happiness is about giving.

MICHAEL EAVIS

83 YEARS BOLD

Michael Eavis is a successful dairy farmer and founder of the hugely popular Glastonbury Festival, which takes place on his farm in Somerset, England.

We didn't expect a legendary figure like Michael Eavis to agree to an interview with us so readily. But agree he did, and the next thing we knew, we were waiting for him in the car park of a very empty Worthy Farm, wondering if we'd got the wrong day. Finally, he drove up in his muddy red Land Rover, wearing his trademark shorts (he's known locally for sporting them year-round) and a huge smile, and ushered us into his office.

Glastonbury was obviously a huge source of pride for him, as was the farm itself. He dashed off to get a vintage festival poster to show us a particularly good year's line-up, before getting distracted by an award he'd won as a dairy farmer. Later, as we bumped along the fields in his car, scouting the festival site for a good photo location, he stopped in front of the empty Pyramid Stage and jumped out,

running us through the bands that had played there, eyes lighting up at the memories. For the photos, he instinctively spread his arms wide, as though embracing his surroundings. His sense of achievement was unmistakable.

This was the best age of his life, he told us. And why wouldn't it be? He'd done everything he'd set out to do – and what's more, he was still doing it. Meeting Michael gave us a much needed shake-up: here was a man about to celebrate his 80th birthday, and yet he found the time to swim every single morning, organise an internationally renowned music festival almost every year and run an award-winning dairy farm. We both work hard, but we're also both avid loungers, able to lie and do nothing for hours on end. Michael remindered us to aim high and keep on track with our goals. One of which is now to go to Glastonbury.

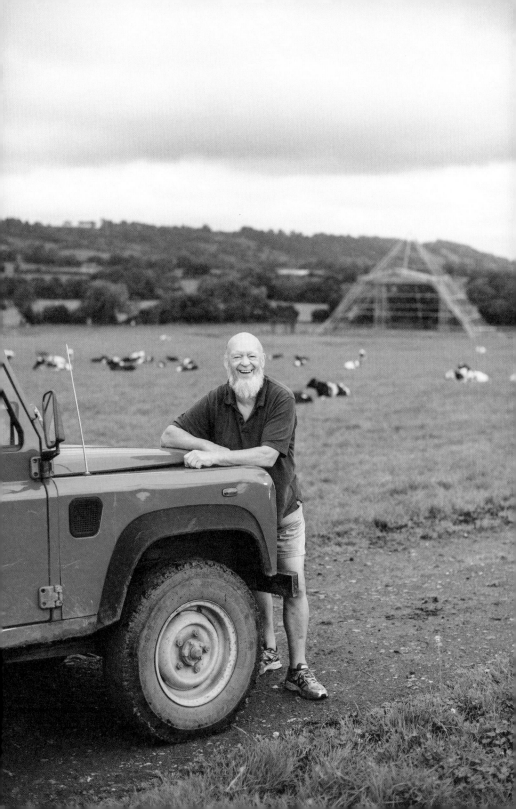

MICHAEL EAVIS

WHEN I WAS YOUNG, I WANTED TO GO TO SEA. We used to sing around the piano as a family twice a week, and there was a picture on it of my mother's cousin, a commander in the Royal Australian Navy – he was the image of success and charm and handsomeness; so I wanted to be like him. Isn't that extraordinary? I didn't even know this chap!

Anyway, so I went off to a training ship for merchant naval officers. I was just 19 and three years into it when my father died, so I had to come home to save the farm. I was the eldest of five siblings and the others weren't really interested. I was only halfway through my national service, so I had to make up the years by working in a local mine for a couple of years. I would milk my cows morning and night after a day shift on the coalface.

I struggled doing two jobs and keeping it all afloat. Eventually, when I got married to Ruth, I was a nightmare and absolutely impossible to live with. Unfortunately, we divorced, but we did have three great kids. I then got involved with a new lady who was called Jean. We became parents to Patrick and Emily, and Jean also had children of her own, so I brought them up as well. There was quite a gang of us. I'm still involved with them, all these years later!

Jean died after 35 years together, and I now live on the farm with my new wife, Liz. She was a midwife in the village, and it was a case of right place, right time. That must be it for me as far as wives go, don't you think? I think three is enough actually!

We have our village baker to thank for Glastonbury. Back in the day, she used to come around delivering bread in her Morris van and she told us about a festival happening just down the road, so off we went. There was no fence or anything and we saw the Moody Blues and all the West Coast bands. I was nuts about it; I couldn't believe it. I thought, 'This is for me,' and I started doing something the very same year, in 1970.

I got hold of the 'White Book', which had all the celebrity contacts in it – The Rolling Stones, Elvis – the lot. I started phoning up at random and explaining I was a dairy farmer in Somerset – it sounded pretty useless really! The Kinks were my first choice, but they pulled out. I was disappointed as I used to play their music to

the cows every milking time! Instead I got Marc Bolan, who was probably a bit more fashionable. About a thousand people came to the first one – not bad for a first effort. It grew every year from that, and now there are millions pre-registered every year. We give two million pounds to charity every time. I think it's a bit of a cop-out if we don't deliver – even if we haven't made a profit.

I don't like drugs and I don't drink much either, but I'm all for freedom – people can do what they want to do with their lives. The hippies used to wear a badge saying 'Don't tell Michael,' but we respected each other really – they were very entertaining and creative.

If I had to choose between the farm and the festival – the farm would always win. We were recently voted the UK's top dairy farm, which was such an achievement, a huge thing for me – and we've also won the highest achieving herd at the Cream Awards. The festival is more precarious. It could go any time.

I'm beginning to feel my age now – as you get older you get more tired, but I think I was born happy really. Some of my contemporaries were born a bit grumpy! Mentally, I'm still fine, and I don't notice people treating me any differently because of my age. Kids in the street want selfies taken with me – they're certainly not saying, 'Here's an old man coming along.' They don't see me like that.

I get up and swim every morning in the pool on the farm without fail. It's good for circulation. Then I have half a grapefruit and scratch out the pith – it takes about 15 minutes out of my life every day, but I read somewhere years ago that it could prevent getting a stroke! I'm not a real health freak, but I do cycle a bit around the village. When you drive, you can never stop for a chat, but on my bike, I can talk to people. Some people love what I do, but some people have gripes, so it gives them an opportunity to tell me face to face.

The best age of my life so far is now. I have the satisfaction of knowing I've made the most of my life. I will die happy – but not yet!

My life motto? You've got to give as much as you take.

HAPPINESS

WE CAN'T BE EXPECTED TO BE HAPPY ALL THE TIME.

That's the first thing. Shit happens, and that shit creates the balance between good and bad that most of us experience in our lifetimes. When we started Bolder, we were pretty realistic about this – but we did want to understand how some people who endure a great deal more shit than others can often seem happier than those who have lead seemingly charmed lives.

What did we learn? A good attitude goes a bloody long way. Our interviewees had endured war, lost relatives and children, experienced divorce, bankruptcy, illness and everything in between. But, for the most part, they had a positive outlook on life, accepting even its darkest twists and turns. One of our very first interviewees, Muffie Grieve, a championship tennis player in her 80s, saw sport as a lesson for life. Her attitude rubbed off on us, so much so that, when we find ourselves feeling negative, we remind ourselves to 'think Muffie.'

We had a similar feeling when we met open-water swimmer Ellery McGowan, who had lost her son quite suddenly when he was just 34. We left her doing lengths at Guildford Lido, humbled and determined to take heed. Grandma Mary, our unbelievably sprightly Los Angeles YouTuber believed that you couldn't rely on anyone else for happiness. She danced around the kitchen after our interview, explaining that this was her daily exercise regime. Jetlagged and exhausted, we could barely keep up with her.

In a video that did the rounds online a while back, the philosopher Alan Watts is quoted, recommending that we look at life like a song. 'People don't go to a concert just to hear the final crashing chord,' he said. In the same way, those that seem able to see life as a series of moments rather than an arduous journey to some unknown finale might just have a better stab at happiness.

MUFFIE
GRIEVE

87 YEARS BOLD

Muffie Grieve has been playing tennis for over 70 years and first played for Canada in her 40s. She recently married her second husband and is currently learning Spanish. She lives in Clarksburg, Ontario.

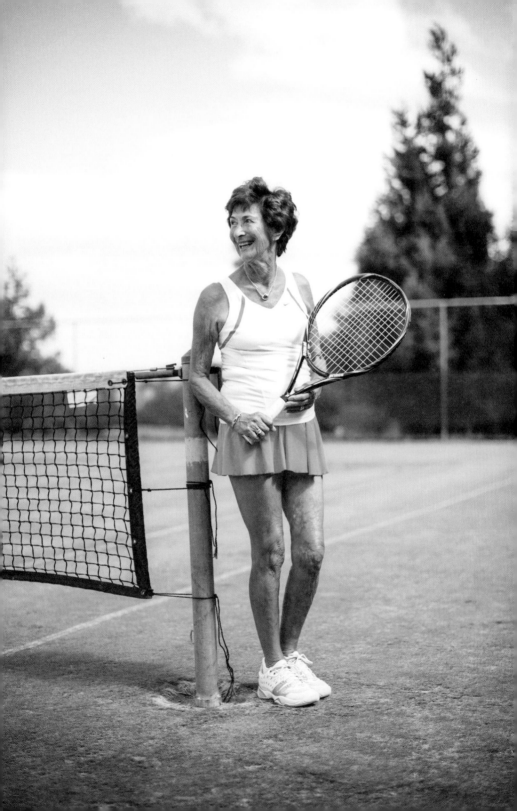

MUFFIE GRIEVE

"**I DON'T CONSIDER MY AGE A FACTOR AT ALL.** It was never traumatic to me to be 30 or 40 or 50 – it just doesn't worry me. As you get older and become a success at something, you gain tremendous confidence. You know yourself and what you want – and you also have the ability to say no to things. The only negative is that your body sometimes lets you down, but what the hell? I see tennis as a lesson for life. You win some, you lose some and you fight again. Nobody goes through life without problems – but you learn to deal with them.

I was evacuated to St Ives [in Cornwall] during the war and started playing tennis there at school. By the time I was 14, I was showing promise and went on to play for my university team in London. When I was in my 40s, I was living in Toronto, and there was a new international women's team in Canada. I got on it, and that was the beginning of a lot of competitive tennis!

So how did I end up in Canada? After university I decided with a friend to go travelling to Australia. The trouble was she met someone, got married and moved to Canada with him before we left! I thought that was a bit of a pain, but then she called and said, 'Why don't you come out here anyway?' I went, planning to go onto Australia afterwards, but of course I got to Toronto and met my husband skiing, and that was that. He had been at my university exactly the same time as me, but we'd never met.

I'm absolutely a feminist and always have been. I have three brothers and I remember my father saying to me, 'Anything the boys can do, you can do too,' which was pretty amazing in that day and age. I was the first woman ever to be president of my tennis club, and my feminist outlook has shone through in my work, too. My first job was in hunting geophysics – we used to do aerial surveys all over the world looking for oil and things, but it was always the men who got to go on the trips. When I told my boss that I'd like to go on one, he looked at me like I was mad and said it was impossible. I went over his head to the chief geologist, who eventually let me go to Spanish West Africa.

I have a very positive attitude about everything. I don't do negatives at all. Bertrand Russell, who I've always admired, wrote a book called *The Conquest of Happiness*, which I read at university. He talks about worrying as a useless negative. Instead he advises looking at the problem and deciding what you can do about it. If you can't do anything, forget about it! It's probably my mathematical, logical outlook, but I've always been like that.

Of course there have been trying times. When I was 62, I had a brain tumour – I found out quite fortuitously on a business trip when I got out of the car and couldn't walk in a straight line. I had a big surgery – seven hours on the operating table. I remember thinking there was nothing I could do apart from be fit – and, apparently, I was. My heart was beating just as strongly at the start as it was at the end. It was unnerving at the time, but what can you do? I think in tennis you learn to pick yourself up and charge on.

A lot of how you age is to do with genetics. Having said that, I am careful with what I eat. I don't like sweet things, which is fortunate. Tennis and golf keep me active plus I walk a lot and go to Pilates. I also enjoy the odd martini and a nice glass of wine. My next goal is to break 90 in golf.

After my first husband died, I was alone for 14 years. My attitude was that if someone came along to enhance my life, then terrific, but it certainly wasn't imperative. I am quite happy by myself. About five years ago I did meet someone – he's 86, a golfer and he's very loving and easy-going. We married last year and had a big family party.

Yes we do live in an ageist society – but it is changing. More people as they retire are staying active: you see older people out skiing, golfing, swimming and travelling. They aren't lying around letting the world go by. Attitudes are shifting, but there is a definite cult of youth.

My life motto? Be positive and never give in.

MICHEL ROUX

78 YEARS BOLD

French-born chef Michel Roux is often heralded as the godfather of fine dining in the UK. Together with his brother, Albert, he opened Le Gavroche and The Waterside Inn, which hold five Michelin stars between them.

We were totally amazed that Michel agreed to an interview, even more so when he invited us to his home in St-Tropez to meet him. Far from being the ostentatious villa we had imagined from a world-famous celebrity chef, his was a warm and welcoming home. Freshly picked tomatoes were laid out on newspaper in the kitchen, dusty cookery books were stacked up all over the place and, outside, tanned nieces and nephews, visiting for the public holiday, splashed about in the pool.

Michel took a whole afternoon out of his schedule to show us around. He picked out herbs for us to smell from his beloved herb garden, walked us through his vineyards and led us to his favourite spot: a shaded nook with a bench where he would often sit and drink pastis as the sun went down.

It might sound a charmed life, but as we sat together in his garden sharing a bottle of Champagne post shoot, Michel opened up about some of his darker moments, including his cancer diagnosis 13 years ago. He was not at all afraid to show emotion as he explained how the cancer had changed him and how he'd come out stronger. He'd since worked on a charity cookery book for the team who helped to bring him back to health and was doing much more philanthropic work, barely any of it in the public eye. He spoke of the importance of giving without the need to receive. This philosophy, he explained, was one of the reasons he agreed to our interview.

Much of Michel's charm lay in this openness and his utter disregard for what anyone else might think of him. Michel knows who he is, knows he's a good person and if you don't like him, that's your problem. It was so refreshing – relaxing – in fact, to be around someone without any need for approval, that we vowed to learn from it. We drove away in the French evening sun deliriously happy – on a high from our day with this infectiously positive man. As he put it, 'You can do what you want in life – be anyone, or do anything!'

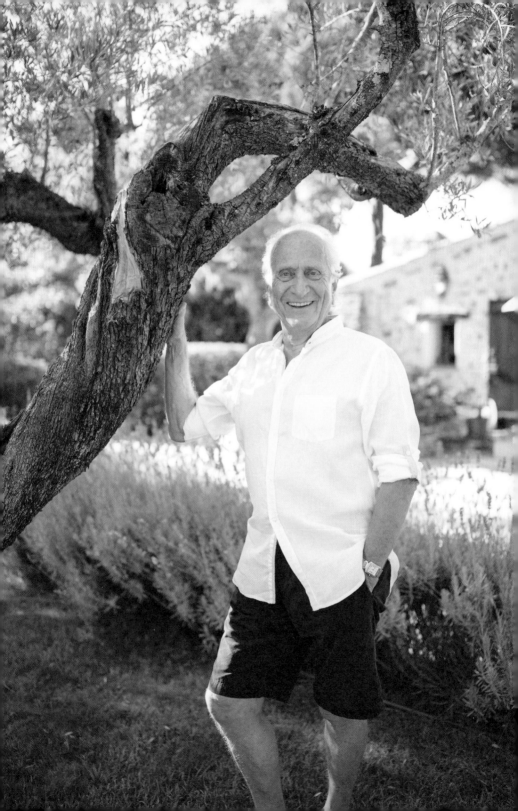

"PERFECT HAPPINESS IS SIMPLY DOING WHAT YOU WANT TO DO IN LIFE & BEING ABLE TO SPEAK YOUR MIND. STICK TWO FINGERS UP! YOU CAN BE ANYONE OR DO ANYTHING!"

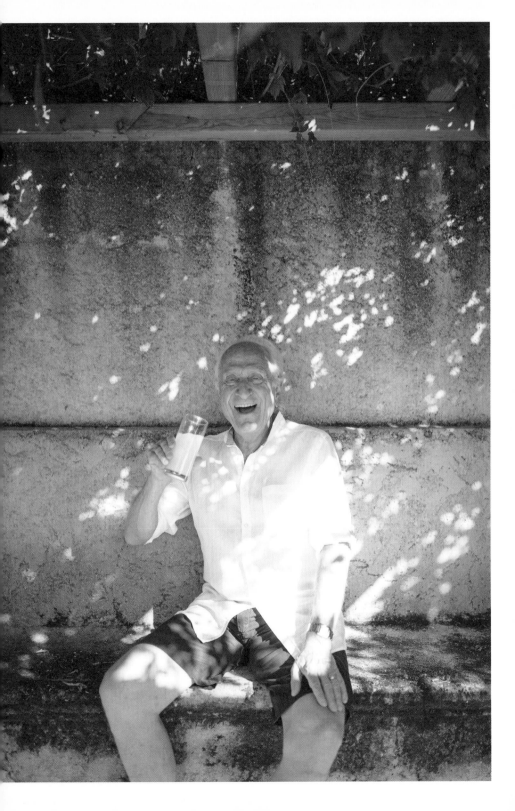

MICHEL ROUX

I FIRST WENT TO ENGLAND TO VISIT MY BROTHER, ALBERT, who was already working there as a chef de cuisine. We loved the country but very quickly realised that the food was in the dark ages. There was nowhere to eat fine food, except maybe The Savoy or The Connaught where it was acceptable, but no real love and care went into it. In a nutshell, the food was shit, so we decided to do something different! I was 28 and working as head chef for the Rothschild family at the time, but we'd always dreamt of opening a restaurant together. So instead of doing it in France, we decided to do it in England.

Our goal was to have the best restaurant in London, and with Le Gavroche we achieved it. In 1974, it became the first restaurant in the UK to receive a Michelin star. Then, three years later, it got two stars, which it retains to this day. We didn't want to rest on our laurels, so next we opened the Waterside Inn, which has now held three Michelin stars for more than three decades, longer than any other restaurant in the world outside France. I am not chasing stars anymore, but I recently opened another restaurant in Switzerland. It's a bistro and a place I love eating, but I no longer spend 10 hours working on dishes. My head chef, Stephane Colliet, does this. The aim is to create food people can afford, using good ingredients.

I spend about four months a year in Switzerland, two in the UK and two at my house in Gassin [near St-Tropez], where I write my books; I've sold over 2.5 million. I travel worldwide the rest of the year giving presentations and masterclasses to young people to help them develop and to tell them the truth about the industry. I tell them, 'If it's not for you, you better know about it now.' It's like having a marriage!

I had colon cancer almost 13 years ago, and it definitely changed me – life is tough when you go through that. You just think about getting to the next day. But after my last treatment of chemo, I thought, 'I must move on and leave this behind.' Of course,

it is there at the back of my mind, but I came out stronger. When the oncologist that looked after me approached me to help with a book [*Recipes for Life*], I was more than happy to – and I recruited more chefs to join me.

Perfect happiness is simply doing what you want to do in life and being able to speak your mind. Stick two fingers up! You can be anyone or do anything! I never believe in any particular party or association. I am just Michel. I am free. My only regret is that I will never know how it feels to sing on stage. When I was a teenager, I won a lot of competitions for my singing. I am a baritone and in my 20s I was asked if I would consider joining the opera. I could have been a success, but you can't do everything, and I had to make a choice. I still sing in the kitchen, though!

My eldest daughter is a gymnastics teacher, and she recently suggested I do a bit of exercise to make up for everything I eat and drink. So I do some stretching every morning and I walk my dog when I can. I also play golf once or twice a month, but I started playing very late in life. Diet-wise, I'll usually have a salad or soup for lunch and something more indulgent for dinner. I've cut down on bread recently, and I try not to drink anything one or two days a week, which is very difficult. I don't smoke, except the odd cigar if I am in total open air and I've had a big lunch.

I don't think I am 78 – seriously! In my mind, I am about 30 or 40. My body is as active as when I was 40. If I start doing 18 holes of golf, I might start puffing on the 14th hole – but puffing is not such a bad thing! As I grow older, I still commit to far too much. I sometimes wake up and think, 'Maybe you could have done without that!' so I am trying hard to restrain myself a bit.

I suppose strangers may treat me differently because of my age, but when they get to know me, they realise I am just one of them.

My life motto is to be yourself. Never try to be anybody else.

JÖRMUNDUR HANSEN

79 YEARS BOLD

Jörmundur Hansen runs a popular thrift shop in
Reykjavik, Iceland. He has also been the head of
the Church of Norse Mythology, a sculptor and
an architect, among other things. He is currently
trying to revive his country's weaving trade.

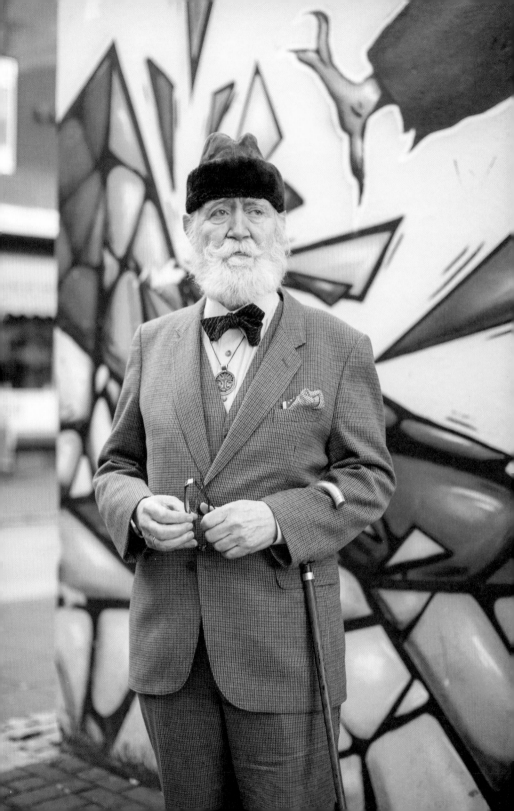

JÖRMUNDUR HANSEN

I WAS BROUGHT UP TO BE WELL-DRESSED and went regularly to the tailor to have my suits made. My shop began because I kept buying clothes as gifts for my relatives, which they sometimes didn't want. All the unwanted items started piling up, so I had to do something with it all. I've been here [in the shop] for four years now, and I will never stop working, I can't imagine how I would pass the time.

I grew up in Reykjavik and still live here now. I was a little abnormal as a child as I was always very interested in older people. At 95, my grandmother used to say, 'I don't know if something is wrong with me, but I always feel like I am 16 inside.' I feel exactly the same; I am both 16 and 79. I have youthful curiosity, which keeps me going; when you're no longer curious, you become old. If you've retired, the best thing you can do is go back to school.

I'm interested in everything from religious history to science; I only wish I had studied more. I realise now that the times when I was learning something new are always the times I look back on with most pleasure. My period at art school learning sculpture was very pleasing, as was the time I moved to Lithuania for a few years to work in the Icelandic horse breeding business. I didn't know anything about horses, but that phase was very interesting as I had to learn a new language and customs and everything was different.

I definitely have a daily routine today, which involves waking early, especially during the summer, when I get up around 4 a.m., and go downtown to have coffee with my old friends. We've been meeting for decades, and we're all in our 70s and 80s now. I open my shop at 2 p.m. and stay there until 7 p.m. Then I'll go home and have dinner. I eat quite healthily, with lots of fish and I drink moderately – it bores me if I get drunk. Instead, I do most of my cooking with alcohol, so I get all the flavours without the effects.

I used to exercise, but I always found it made me gain weight. I exercise nowadays by standing on the bus instead of sitting on my way to work – it works wonders. I did smoke for a while, but then I got a cancer of the throat and agreed with the doctor to

"People who think they can fulfill their lives by having more 'stuff' are missing the point. The best things you can collect are experiences & good memories."

stop. I now enjoy one Havana cigar every New Year's Eve, although I've forgotten the last three years. It was never a problem for me to quit.

I don't think anyone treats me differently because of my age, but maybe I just don't notice it. Possibly young people think older people are obsolete, but it's not so bad here in Iceland. Lots of people keep on working. My grandmother was still working until she was well over 90. She was a herbalist and would run up to the mountains to get ingredients. Even when I was 16, I had difficulty keeping up with her.

The most important lesson I've learnt is that you have to be content with what you have. We are too prone in modern society to collect goods and money – although I shouldn't be advising this given that I am trying to sell people expensive suits every day. But people who think they can fulfill their lives by having more 'stuff' are missing the point. The best things you can collect are experiences and good memories.

It's also important to keep good relations with your family and friends. Cherish what you've achieved and be consistent in the things that you do. Or, as the Americans put it, KISS – Keep It Simple, Stupid!

MICHAEL WOLFF

81 YEARS BOLD

Michael Wolff co-founded Wolff Olins, one of the most successful design agencies in the world. More recently he runs Michael Wolff & Company and is involved in a new brand, Spring Chicken, focused on improving design for older people.

It was such a boiling hot day when we met Michael Wolff that we were able to do the whole interview on the leafy terrace of his North London home. Before we started with the questions, we couldn't help but mention how incredibly young he looked. He laughed out loud and told us he agreed. The tone was set for an informal interview, full of fun. He was far more concerned with us having a good time together than discussing his legendary status as a designer, which he insisted was down to a series of lucky breaks.

Michael's innate sense of cheerfulness was infectious. As we all sat together chatting in the sun, he'd often stop to scroll through his phone to show us something – an email from a friend, a clever cartoon – that had made him laugh, hoping we'd love it, too. We both appreciated the fact that age hadn't knocked humour out of him. Some of the things he spoke about had clearly been painful – his experiences at school in particular – but he seemed to be able to look at life, however dark, and find the light in it. He recognised that each setback had led him to where he was today.

Michael's ability to shine a positive light on life's challenging moments was admirable, and we could both see that there was real value in his attitude. Embracing that attitude ourselves, though, has sometimes proved more difficult. Is it really possible to look on the bright side when there is a serious illness in the family or when a partner is desperately unhappy? We'll get back to you on that. Life hasn't always turned out the way we expected or hoped, but at the very least, Michael helped us to see that there is usually something to be recovered from the wreckage.

The smaller stuff: the lost laptop, the bad date, the missed flight – is far easier to shake off and, sometimes, when we find ourselves taking life far too seriously, we'll remind ourselves to lighten up. Laughter, the medicine that Michael so thoroughly endorses, is free, and we should all make it a priority.

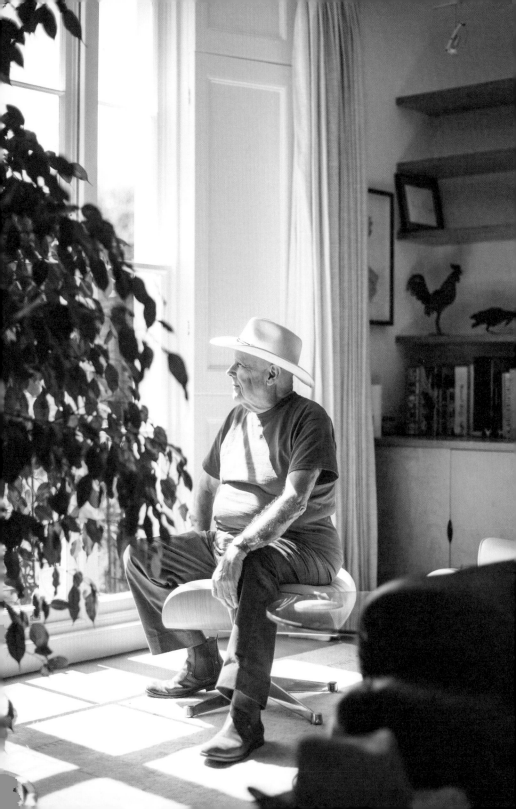

MICHAEL WOLFF

WHEN I WAS 26, I USED TO LOOK ABOUT 14, which was terrible. I suffered enormously from looking too young. Now, it's ▬▬▬▬▬ revenge time! My age just is People see you through some sort of filter at whatever age – there's a huge amount of invention that goes on in the world. With me, people invent this design figure. Young students treat me with a certain amount of awe, which is irritating. I want to connect and be useful to them, so I have to try to break through it.

My parents are Russian, but I only spoke the language until I was about six. I didn't see a lot of them. When they came to visit, I'd think, 'Who are these strange foreign people?' I was sent off during the war to a nursery in Devon [in England] and from there I grew up in a series of dreadful schools. I remember I trod in a wasp nest in one of them and got about 25 stings. I was told not to cry or show emotion. The schools equipped me with an understanding of what happens to human beings in institutions of all sorts. I'm very conscious of how much abuse of hierarchy there is in corporations.

I just about survived school and was probably considered remarkably unsuccessful by everyone who taught me. I still don't like training – I think it's for dogs and horses. Inspiring people and motivating people is fine, but they have to learn for themselves. I got my jobs out of sheer charisma. I largely bluffed my way – but I also found that I had a way of approaching design that was unusual. I like to see the truth of what is there and reveal it. I was always a 'draw it out' rather than a 'stick it on' designer – the world is full of the latter.

My career was built on an amazing series of accidents really. At some point along the way I met Wally Olins, and we hit it off. He was like a duck – he always wanted to get somewhere, whereas I was the seagull, floating on the thermals. He had a

vast number of qualities that I lacked, and we made a good team. My alternative life would probably have resembled Jack Kerouac in *On the Road*. I would have enjoyed being a literary tramp!

Perfect happiness for me is walking through Regent's Park – there are people from all of the world in the world, speaking different languages, strolling around at peace. I see it as a model of how the world could be. Every time I go, I discover new trees and I love the two black swans – they eat right out of your hands. And I love walking. It's the only exercise I bother with.

At the moment I'm involved in a retail brand for older people called Spring Chicken. There seems to be a myth that older people love terrible design, which is all bollocks. There still isn't even a decent wheelchair. A lot of the products that people sell to my generation are absolute crap. Spring Chicken aims to bring beauty and design into everybody's lives so there isn't an excommunicated older generation. I'm very excited about its potential.

I have no regrets. I wake up happy. If I'd have done anything differently, even missed one train, I wouldn't be where I am. I am much better at getting people to open up now that I'm older. I'm no longer as scared of people, and I see humour in practically everything. I need to laugh several times a day – it's the most important thing in my life.

The best lesson I've learnt is to watch out for the immorality that goes with greed. People will trample on other people if their greed gets out of control. I've also learnt to be compassionate – to always imagine myself in other people's shoes.

I won't retire. Even if I'm sick in a hospital bed, I shall still be asking, 'Who designed this disgusting blanket?'

REGRETS

IS IT POSSIBLE TO GET THROUGH 70-PLUS YEARS OF LIFE WITHOUT HAVING REGRETS?

Given that most of us can already rack up quite a few by our mid-30s, the answer is probably no. And, wow, do regrets sting. Our interviewees were sometimes still visibly affected by their own bad choices. That's what regrets really are, after all. Bad choices. Life can throw endless crap at us, but we have no power over much of it. Regrets emerge when we did have a choice, but we made the wrong call. That hurts and haunts us – at any age.

Gordon McVie, our 71-year-old oncologist, might have saved millions of lives through his work in cancer treatment, but he was horrified at the mistakes he made in his first marriage. 'To my utter disgrace,' he told us, 'I put everything, including my work, before my family.' Eighty-six-year-old tattoo artist Doc Price regretted falling in love so easily while he was married. Frances Dunscombe, meanwhile, broke our hearts when she told us she wished she had realised what she was capable of when she was younger.

So yes. Regrets. We all have a few. And while it's easy to spend time fretting and obsessing over them, Bolder taught us that the secret wasn't to repress regrets via some sort of delusional bravado – it was just to look at them in a new light. As 81-year-old design guru Michael Wolff explained, every missed train, every dreadful school experience and every bad choice he'd made had taught him something.

The happiest people we've met have learnt not to fixate on failures or have simply reframed them as an important part of their life's journey. The secret, they taught us, was to surrender to life's inevitable failures – accept your bad choices and learn from them. Isn't that a good idea? After all, what use do they have otherwise? Allowing regrets to linger, Zandra Rhodes told us, will keep you living in the past. They'll stop you from moving forward. Ain't that the truth.

ROBERT BURKE

80 YEARS BOLD

Royal Air Force (RAF) Squadron Leader Robert Burke was learning to be a fire-eater by the age of 12 and has since been a test pilot, a stunt man, a motorcycle racer and much more. Today, he is one of Britain's leading polo coaches.

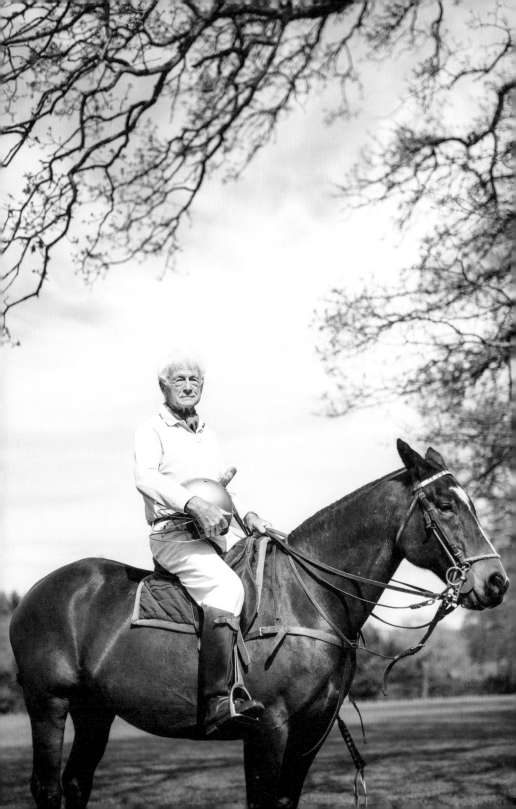

ROBERT BURKE

BY MY 40S, I'D ALREADY BROKEN A LOT OF BONES from racing motorbikes, so when a friend recommended polo, I took him up on it. Polo is one of the most exciting sports I've played but it's also the most difficult. I was not a natural, which I think has helped to make me a successful coach. Providing players have the necessary aggression and competitiveness, anyone can be good. I get a total cross-section of people learning – and even some celebrities over the years. A lot of pop bands used to want to learn back in the day – Kenny Jones, Mike Rutherford and Stewart Copeland of The Police to name just a few. The oldest person I've trained is the architect Lord Foster. I taught him in his mid-60s.

I don't think we live in an ageist society – actually, I think things have improved for the older generation. I take a lot of exercise, and I am interested in an enormous number of things, which helps to keep me young. Plus, I only sleep for about five hours a night, which enables me to cram quite a lot into my days. As an older person, you can pretty much say what you want – it's not going to affect your career – plus you have a lot of experience, which enables you not to upset people by mistake.

I was conceived on the banks of a volcanic crater in Indonesia while my parents were on their honeymoon. My father was a pilot in the RAF and was sadly shot down and killed before I was a year old. My mother married again in 1946, so I grew up with a stepfather and three half-siblings in Buckinghamshire and East Kent.

When I was very young and went to stay with my grandparents, there was a circus nearby with a fire-eater. I was fascinated and asked him to teach me – back in those days you could do that kind of thing – so he taught me, aged 11. The last fire-eating show I did was underneath the London Eye about eight years ago. It was a nightmare getting clearance from the police and numerous authorities, but I did it!

Almost everybody from my prep school went on to Eton [school] except me. I had a long struggle with my parents as I wanted to go to St Edwards, Oxford where many of the most famous RAF pilots went. After injury at RAF college, I spent three or four

"Life is not a dress rehearsal. I always advise everyone to live their lives absolutely to the full."

years doing a variety of things including car racing, film stunting and cabaret as a fire-eater. Then I rejoined the RAF.

My idea of perfect happiness revolves around my wife. My flying instructor had a spectacular crash and died right in front of me. I later married his young widow and we now have two grown-up daughters and a son. We have been happily married for 52 years.

I don't have any regrets – I've had an amazing life, I've tried everything I wanted to, and been paid to do things that I love. I am definitely a person who, when the bread falls off the table, it lands butter side up. Even things that have looked bad at the time have turned out OK. I've been very lucky.

The only thing I haven't done yet is a bungee jump, so that's still on my list. Most of the young people in my extended family have had a go, so when I get around to it, I will have to do a bigger one than them! There's a new one in Switzerland which is higher than any that they have done.

Life is not a dress rehearsal. I always advise everyone to live their lives absolutely to the full.

FRANCES DUNSCOMBE

83 YEARS BOLD

Frances Dunscombe was snapped up by Grey Model Agency aged 82 and has already appeared on the catwalk at London Fashion Week and in a photo shoot for Rankin's *Hunger* magazine. She also starred in ITV's *Secrets of Growing Old*. She lives in Surrey, England.

Frances answered the door of her Surrey cottage dressed in jeans and a powder blue shirt, long hair pulled back, every inch the off-duty model. She'd been snapped up by a modelling agency the year before we met, but she'd clearly already had an eye for fashion. She seemed delighted to finally be working in an industry she was passionate about.

Later, as she talked us through her modelling portfolio, she told us her biggest regret, which silenced us both as we sat either side of her on the sofa. 'I wish I'd realised I was capable of more sooner in life,' she said – and her words made a huge impact, not just because they were so heartfelt, but because we've heard so many others express the same sentiment. It was clear that her recent modelling successes meant an awful lot to her – she'd just appeared in a catwalk show at London Fashion Week and had posed in Prada for a glossy mag to boot – but there was an element of sadness in her tone. A sense of regret for missed opportunities and what might have been if

she'd started believing in herself sooner.

Women, in particular, constantly downplay our skills; we shy away from admitting to our strengths, to the point that we sometimes lose confidence. It seems such a huge waste. We are the queens of self-deprecation. Often, we'll bring that attitude into work, and then discover, to our horror, that our colleagues – or worse our bosses – have taken us at our word. When people start reflecting your underplayed beliefs back to you, it becomes all too real. Hearing Frances motivated us to put a stop to false modesty, or at least try to embrace the attributes we know we have. Often, if one of us is having a wobble, we'll remind each other that we need to be our own biggest backers. A shift in fortune often magically follows.

Since we met, Frances has gone on to do much more, even posing nude for photographer Josh Redman. If she didn't realise earlier what she was capable of, she is certainly making up for it now.

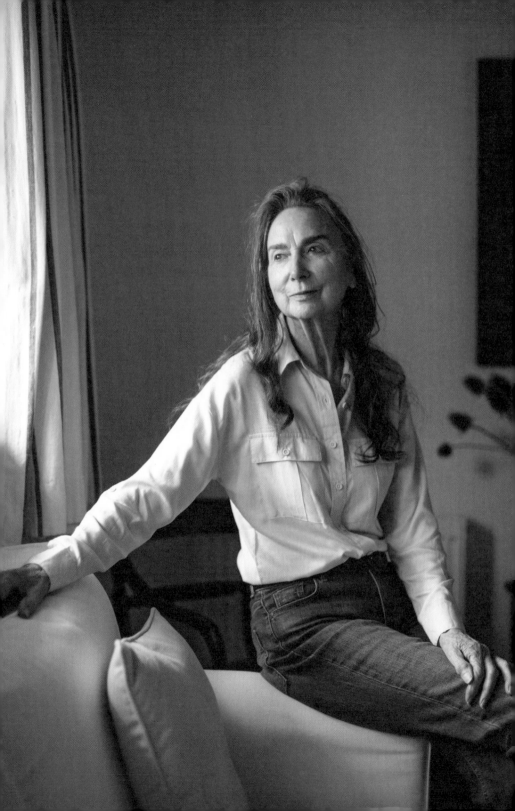

FRANCES DUNSCOMBE

I WAS BORN IN STREATHAM [IN LONDON], the fifth of six children, and we were quite poor, but respectable. I say this because London evacuees were always portrayed as dirty and scruffy. This certainly didn't apply to us. We were always spruced up: my mother used to make our dresses as well as my Auntie Florrie, who produced beautiful clothes from her second-hand shop, which was in Blackheath [in South London].

We children were evacuated during the war, and I eventually ended up in Llanelly, South Wales. Although my sister, Roma, was asked to stay with me, we were soon parted – she to one billet and I to another. So off I went on my own. Before evacuation, I'd been quite the entertainer; I used to stand on the kitchen table and imitate Shirley Temple! But separation from my parents deprived me of any source of encouragement, and, apart from being given large parts in school plays, there was nobody to recognise or nurture any possible talent.

My lack of qualifications left few options open to me when I finished school at the age of 15, and I ended up working as a typist in London's Midland Bank on Old Broad Street. We used to go out for morning coffee, and it was in The Long Room, a coffee house, that I met Ralph, who was a member of the London Stock Exchange. I didn't realise it at the time but he had not long been out of the army where he had been a captain involved at D-Day in Normandy.

Poor Ralph, I kept him waiting about five years until I agreed on a date to marry him. I only just made it in time – there were a few others waiting to step into my shoes. Ralph was a great character with a fine sense of humour and quick wit, which is what attracted me to him in the first place, although he couldn't dance for nuts. He would sit smiling to himself as I twirled around in the kitchen, even when he was in his 70s. Sadly, he suffered from vascular dementia for about seven years and died five years ago. He would be so pleased for me if he could see what I am doing today.

Grey Model Agency is doing a great thing for ageism. They are helping to bring older people out of the shadows and are showing us off. There's sometimes an attitude towards older people who don't conform of, 'Who does she think she is?' For instance, when I first wore tight jeans, I received some strange glances from the locals. However, the fashion eventually caught on! Grey is helping to show that you don't have to have one foot in the grave at a certain age.

I'd say I am still energetic. I mowed the lawn and played squash into my 70s and I still try to walk a lot. I eat plenty of fruit and veg and have half a glass of wine at lunchtime every day. I can't sleep if I have it too soon before bed. My only beauty regime is to wash my face in the mornings and cleanse at night. I never use soap – just water.

I do have regrets – so I can't really sing along with the Edith Piaf song – but then again, everything has worked out so well. My three grandchildren have given me the happiest days of my life. I wish only perhaps that I'd realised I was capable of more sooner in life. I heard Dame Carol Black saying something similar on *Desert Island Discs* the other day. There are so many avenues I could have taken.

My life motto is be positive.

"I wish only perhaps that I'd realised I was capable of more sooner in life."

"IF YOU HAVE REGRETS, YOU LIVE IN THE PAST & DON'T MOVE FORWARD IN OTHER WAYS."

ZANDRA RHODES, 79

"ONE OF MY
GREATEST REGRETS
IS NOT ASKING MY
PARENTS MORE
ABOUT THEIR
LIVES."

SILVIA PASKIN, 72

ELIZABETH SEABROOKE

92 YEARS BOLD

Elizabeth Seabrooke hit the headlines after 2018's Notting Hill Carnival when photos of her dancing with fellow carnival goers in the pouring rain went viral.

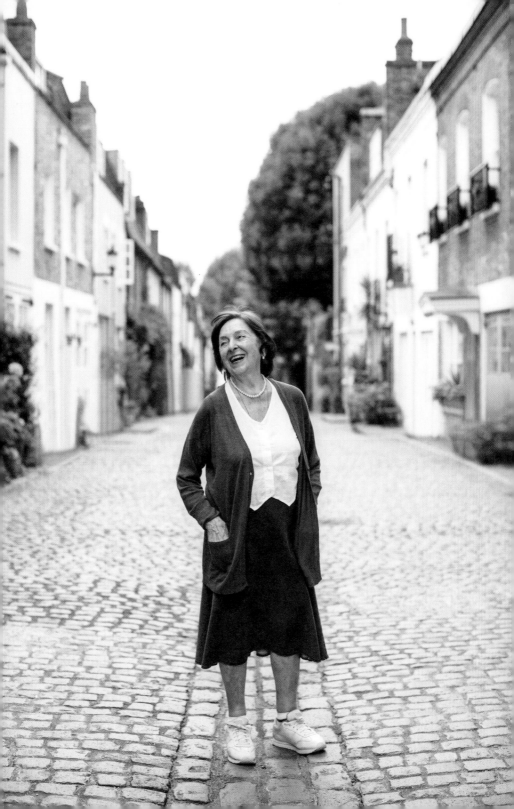

ELIZABETH SEABROOKE

I'VE LIVED IN NOTTING HILL FOR A HANDFUL OF YEARS, and my son took me along to the Carnival. I was pleased to be there and support it, why on earth shouldn't I, after all? It was such a happy day – no wonder it takes a year to organise. I was twirled around and around by this beautiful man, and of course it was caught on camera and got lots of coverage in the media. I thought he was such a good sport to dance with me – even though I felt I was moving like a bunch of sticks!

I wanted to be an actress when I was young and I got into the Royal Academy [of Dramatic Art], but I wasn't allowed to go because my parents thought it wasn't respectable. In those days I did as I was told, which was a great pity. You could say I was a good child, but really, I fear I was spineless. I wish I had been defiant and spoken up for myself. Instead, I did everything I was told to do. I regret that.

I have three wonderful children, who in many ways have been the greatest achievement of my life. My main priority was always to let them be themselves. I was determined that I was not going to stand in their way; whatever they wanted to do, I would support. I didn't want them to be obedient in the way I had been all those years ago.

In many ways though, I feel like the richest woman in London. I am an optimist and I suppose I am not very introspective. What I know about myself is from what other people have told me. I haven't noticed people treating me differently as I've got older – but then again, I truly don't feel like I'm old.

I had the most wonderful father. I know I'm his daughter, so I'm biased, but he was really special. He died 71 years ago, 10 days off my 21st birthday, and I think about him every day. He taught me so much that something happens on a daily basis to remind me of him.

"I WISH I HAD
BEEN DEFIANT &
SPOKEN UP FOR
MYSELF."

GRANDMA MARY

88 YEARS BOLD

Grandma Mary became an internet sensation along with her two sisters after a video of them all discussing the Kim Kardashian sex tape went viral, getting almost four million views. They have since appeared on *Oprah* and launched their own YouTube channel, 3GoldenSistersTV. She lives in Los Angeles, California.

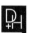 Think old people are too embarrassed to talk about sex? Think again. Grandma Mary wasn't the first interviewee we met who was far more comfortable talking about sex than we were – but she was perhaps the most outspoken. We'd expected as much – given the viral YouTube skits she did with her sisters – but we were still surprised at how open she was about her own life. It's one thing talking about the Kardashian sex tape or *Fifty Shades of Grey*, but it's quite another to talk about your own life between the sheets.

Mary's husband Jack had died five years back, but as she danced around her kitchen, demonstrating her exercise regime, she explained that while she loved her husband, she was experiencing a kind of freedom and independence she'd never known before. She'd met him when she was 15.

In our mid-30s, single at the time, and immersed in the fickle world of online dating, we couldn't begin to imagine how it would feel to be with one person for life. It might have been one of her regrets, but for us, there was something appealing about a life spent with just one partner. It did get us thinking, though, about how lucky we were to have options. We spent a long time regretting failed past loves, and imagining a life filled with remorse if we didn't 'find someone.' Mary made us think again. 'Single at 36?' she said, in awe when she asked about our lives. 'Lucky you!' What a refreshing response that was.

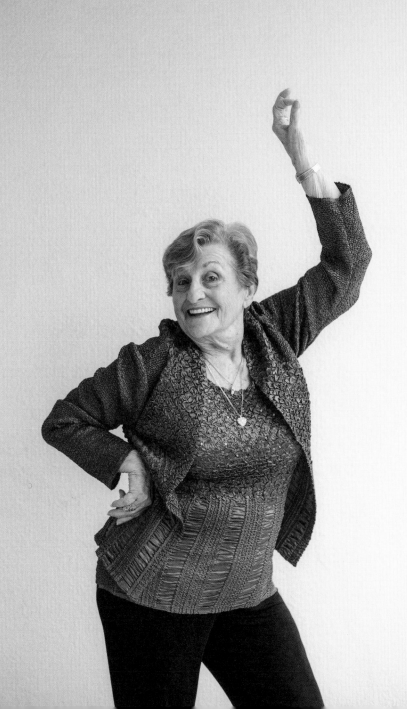

GRANDMA MARY

I WAS A HAIRDRESSER MOST OF MY LIFE – doing that job you listen to people all day long and you become a bit of a psychologist. You go home grateful for what you've got. It made me feel one of the luckiest people in the world – even though I knew I wasn't. I grew up in the Bronx and dropped out of school early. Growing up in New York, you get an education without an education. You're outdoors all the time; you quickly learn what life is all about. There were six of us kids and we were very poor, but we loved each other. Money isn't happiness.

At 15, I had my first kiss with Jack, who was to become my husband. That kiss melted me away, and then he took my virginity at 17. In those days, you had to marry the guy – how stupid is that? Now, women can sleep with a hundred men and then get married. Anyway, my parents hated him because he was Polish, not Italian like us – they'd have preferred me to marry Tony Tintorello, the local butcher. We had a great marriage, though, and we had two sons together. They are both in their 60s now, but they still come over for lunch every Monday.

To tell you the truth, when my husband died five years ago, I felt free. Like I'd been let out of a cage. I'm the merry widow! We had a great life together, and I knew he loved me unconditionally, but if I so much as touched his toe he'd be on top of me! He was so jealous, too. He used to say, 'I married you to be with you 24/7.' And if you think you're going to change someone, you can't. You can change yourself maybe, but not someone else. The genetics, the blood that goes around them, it's not going anywhere. If you have kids together, you'll see they are half of each of you. I think the secret to a happy marriage is not to take anything too seriously. Any bad things Jack said to me went in one ear and out the other as I knew he was crazy about me.

Regrets? I would have loved to sleep with a bunch of other men. I wouldn't date now, though. What are we going to do? Men take too long and I'm too tired for that. I would like to date for companionship, but not for going to bed. Maybe with the lights out! Anyway, I'm happy by myself. I think happiness is self-inflicted. I say that

"Regrets? I would have loved to sleep with a bunch of other men."

to everyone. You can't wait around for somebody else to do it for you. I keep myself busy, too. If you're bored, you're boring.

I look crappy now. I used to be pretty, but I don't care. I would never get plastic surgery – everything is within you. I had a girlfriend with a face like a potato but after 10 minutes you fell in love with her – you forgot what she looked like. It's the same with men. They can have a big nose or be cross-eyed but speak to them and everything changes. I wear perfume every day, though. I buy it when I win in Vegas. Men come up to me and tell me I smell nice – apart from one guy who told me I smelled like his dead wife, the jackass! Fashion is not important to me, although I have picked out a beautiful dress for when I die. There's so much more I want to do before that, though.

I'm free of pain, so I'm very lucky. My friends all have knee replacements or hip replacements. I dance for an hour every morning – that's my exercise. I don't want to go to a gym, so I go around every single room in the house dancing polka. I relax a lot, too. It takes a very intelligent person to do nothing well – I've got that phrase embroidered somewhere. I nap every day, and I love food. I eat my last meal of the day at 2 p.m. with a glass of wine, so at night before I sleep I'm thinking about what to cook the next day. Baked macaroni, meatballs, spaghetti, stuffed lamb shank, braciole – everything. I'd really like to do a cookery show. That's what I want to do next.

My life motto? Laughter is the best medicine.

DEATH

OH DEAR, WE'RE ON THE DEATH CHAPTER.

That's what we're all skirting around, isn't it? And skirting around it is key, really. After all, we wouldn't want to be actually TALKING ABOUT IT. Goodness, no. Let's just have it niggling away somewhere at the very back of our minds, where it's safely out of focus.

When we started Bolder, we thought it would be the ultimate no-no to talk about death, especially to old people. How insensitive! Our contemporaries didn't even want to talk about it, so anyone edging closer to the grave would be in even greater denial about it, right? Not really.

When we finally got around to asking about it, nobody batted an eyelid. We were the only ones squirming. Joyce Williams, our octogenarian blogger, told us she actually worried about it more when she was younger, as so much of life remained unfinished back then. Now, she said, there was a sense that life had come full circle. Even funerals had become relatively happy social occasions, which shared the same space as 80th birthday parties and 50th wedding anniversaries. Lives were being celebrated across the board, not commiserated.

That's not to say that pushing up the daisies is all ... well, roses. Our interviewees often told us that, while they'd come to terms with death, they still feared the act of dying. As Doc Price, our tattoo artist, explained, he was old enough to have seen his friends suffer in varying degrees and knew that dying was a very different experience for everyone.

Our interviewees all had one vital thing in common: they'd survived beyond the age of 70, although far too many had lost friends, relatives and children far too early. Death, perhaps at its cruelest, strikes too soon – and its unpredictable nature means we can't ever take life for granted.

Perhaps that is the takeaway, then. Not to fear death itself but to fear frittering life away, while we still have the chance to savour it. Glastonbury Festival founder Michael Eavis, for example, told us he'd die happy, as he'd achieved everything he'd ever set out to do. That's quite the privilege – and some of us won't reach the dizzy heights that he's managed. But we should at least die trying.

DOC PRICE

86 YEARS BOLD

Doc Price is a tattoo artist based in Devon, England. He opened his own studio in the 1950s and has since built up a devoted following. Today, he judges at tattoo conventions all over the world and is believed to be the world's oldest working tattoo artist.

We travelled to a tattoo convention in Bristol to meet Doc, a perfect example of Bolder taking us to places we'd never otherwise go. We hadn't realised his legendary status before we arrived, and it soon became clear that we'd have to take him away from the never-ending stream of diehard tattoo fans wanting to say hello if we were to get anything done. We ended up huddling together on a free bench outside the train station. Not the ideal setting for an interview, but once we got talking, the background hustle and bustle quickly faded to nothing.

Doc admitted that he was horribly hungover and that we'd caught him on a bad day, but as far as we were concerned, he was wonderful. Relentlessly honest and surprisingly philosophical, he spoke to us as though we were old friends. There had been affairs, deaths and failures, he told us, but also a huge amount of love, passion and success in his life. None of it was off limits, but his comments on death lingered with us as we travelled back to London.

For Doc, death was nothing to fear. That's something we heard from a lot of our interviewees, when we dared to ask. But he also got us thinking about the act of dying, as opposed to death. He'd given up smoking years ago because he didn't want to die of cancer. Twelve black belts in martial arts later, he was fighting fit.

When we speak about our collective fear of dying, we are often talking about our fear of not existing anymore. Doc's comments made us think that our fears were misplaced. We won't know about it when we aren't here, but we'll certainly know about it if we suffer in the process. There's very little we can do about it, of course, but while none of us can aspire to live forever, we can at least hope for a peaceful death. Or, we could do as Doc does and stop thinking about it altogether.

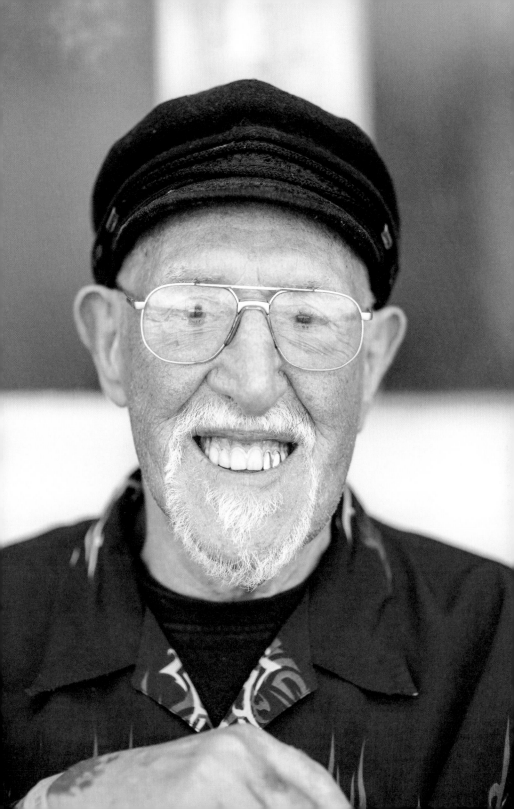

DOC PRICE

MY FIRST TATTOO WAS A HEART with 'mother' written in it. It was permissible back in those days to get a tattoo at age 14. And my mum couldn't get too angry because it was in homage to her! It wasn't an act of rebellion, though: I just wanted one. I have 48 of them now, and I still cry inside when I get them done to cope with the pain.

I couldn't read or write until I was about 20, but I could draw all day long. I still do now as a routine practice for my own satisfaction. Tattooing is a creative art, and having a vivid imagination is a gift as it allows you to float in and out of reality. Retiring is a joke. It implies you don't have to do anything anymore, just as you should really be starting to do things. I still work every day and love it. It's a rare thing to have a passion like that. If you can afford it, follow your heart.

I got married when I was 22 – I was in an egg-packing factory as a labourer and she was at the end of the production line. She was very beautiful, and I knew if I didn't make the first move the moment would pass, so I just got on with it. We went on to have two children together, and today I've got lots of grandchildren and four great-grandchildren. I didn't necessarily plan to have children – it just happened. But I am pleased I had them. They carry on the legacy.

My son works with me in the studio, but my daughter is like me in character, in that she doesn't need to speak to me from one year to the next. When we do meet, though, it's like we've never been apart. I love her dearly, but I am not attached to every detail of her life. People interfere with their children too much, and I think it can bring on great sadness. The children can't ever develop their own personality.

I fall in love at the drop of a hat, and I did so when I was married. I acted on it, too, which I regret. If you lack inner confidence as I did, you have to prove yourself all the time. Loving another person is not always true love. Loving without attachment is the real thing; when there's nothing to gain, nothing to seek. But we pay more attention

to the love that we see on films and in fairytales. We have unrealistic expectations for relationships, and that can be a common cause of failure.

My wife passed away in 2007 – I've had relationships since, but they don't work as well. I believe that being alone is our normal and natural condition – when we attach ourselves to people, life becomes too complicated. And I think anyone who makes you feel bad for being alone is jealous. If you're solo, you're free. Some people like the obligations that come from a partner and the stress that brings; other people don't. It's quite simple.

I don't really think about fitness or health – although I do have 12 black belts in martial arts and I also make swords, which is quite physical. I gave up smoking seven years ago, too – I didn't want to die of cancer. How you die is a serious matter, but death isn't. People farm the elderly off into homes, which is a tragedy. Living forever isn't an option, so I always live in the moment. Dying is a once-in-a-lifetime experience. I don't worry about it.

My life motto? Stop thinking. Just be. When we think things, those thoughts become real to us and bring us into conflict. God designed us to look outwards, but we as humans seem to have the ability to look inwards. Meditation is one way of curbing our thought process – just be quiet and present in your own person.

Can you show me an imperfect cloud? It doesn't exist.

"Dying is a once-in-a-lifetime experience. I don't worry about it."

"MY SON'S DEATH
MADE ME EVEN
MORE AWARE THAT
IT'S IMPORTANT NOT
TO PUT THINGS OFF.
I STILL HAVE A LOT
OF LIVING TO DO."

ELLERY MCGOWAN, 73

"LIFE INVOLVES
RISK, WHETHER
YOU LIKE IT OR NOT,
EVEN IF YOU'RE
JUST CROSSING
THE ROAD."

ALAN GRIEVE, 89

JOYCE
WILLIAMS

84 YEARS BOLD

Joyce Williams is a former physiotherapist who took up blogging aged 80. Her blog talks about ageism and fights the stereotypes that surround getting older. She lives in Glasgow, Scotland.

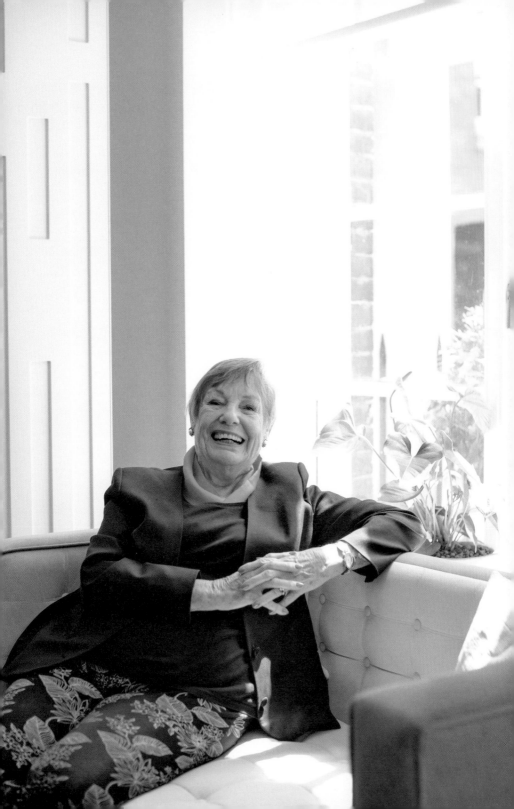

JOYCE WILLIAMS

I WAS 80 WHEN I STARTED DOING A BLOGGING CLASS.
The rest of the class were in their 30s, but there was a good exchange
between young and old; they were very willing to untangle all the
jargon for me. I decided to write about being old to fight the doom and gloom that
surrounds old age. I was looking around and the reality wasn't anything like the
media suggested. My contemporaries are just as happy, if not happier, than before.
I thought I needed to explain in my writing that these years are bonus years to be
enjoyed. You've got time, but the number of 'oughts' and 'musts' disappear. That
whole pressure is off.

I also wanted to write about sex in my blog as a direct response to the reactions I
got in my blogging class. Every time they spoke about it, they were looking at me as
if to check I was OK with it. They couldn't imagine people my age having sex. But, of
course, it's just as good now as any other age. Why would it be any different? You're
still human, you still like being touched, but you've got more time. Dating sites for our
age group are very active.

My first husband died when I was 45 – he was the love of my life, and for the first
three years after he died I was totally depressed. He told me to go travelling, as
that's what we'd always planned to do together. So I got a Lonely Planet guide and a
rucksack, and got on the plane. I didn't care if I lived or died at that point, which was
a bonus, as it meant I had no fear. I haven't stopped travelling since. When you travel,
you are no longer yourself; you can be who you like. Not only that, you are proud of
yourself for being 'me, here, in this place.' You get a kick out of it.

Looking back, I realise that everything has turned out well. There was that awful
depression in the middle when I thought my life had come to an end and I couldn't
believe I could ever be happy again. But I got on with work and it saved me. My
mother had always told us we were superior, so I think that instilled a certain
confidence in me. I fell into physiotherapy by mistake really, but it ended up being
brilliant. I joined at a time when it was growing as a proper profession. It was mostly
women, too, so there was room at the top. It was superb.

I think physio has helped me in other ways, too. I don't exercise, but I do know what to do when things start to slide. I do a stretching and strengthening routine every day, and I get out walking. For most people, doing anything extreme is damaging to the joints. Go up hills, walk regularly, swim regularly, but don't injure yourself doing extreme sports. Always ask yourself, 'What do I want be fit for?' Why do you need to run a half-marathon? Often it's for the ego; it's not about real fitness.

When you're 84, you know you could be dead in two or three years, so you do think about death, but it isn't such an issue anymore. I was much more worried about it when I was younger, because life was so unfinished back then. When you're older, you have that sense that you've come full circle. You begin to say goodbye to things; we have a good spring and I know it might be my last. It sharpens your enjoyment when you stop to think like that. I might look more closely at a flower or a spider building a web – things that I didn't have time for before. And I enjoy watching small children in a way I never did. It's the next bit of life happening.

Even funerals have become happier – people are celebrating life because it hasn't been cut short. I go to a lot of social gatherings – some of them are 80th birthdays, some are big wedding anniversaries and a whole load of them are funerals. It's the same people alternating between them all in one year – it becomes part of your social life. My current husband was the husband of an old friend of mine, and I only got to know him properly after she died and we got together to remember her.

My best age is now. The only frustration is I want to know how it all works out – what will happen with Brexit in 10 years' time? What will happen to my grandsons in 20 years? I don't believe in the afterlife, but I do wish it was true as I'd love to look down and see what's going on!

There are things I can't do anymore, but I can live on the memories of doing them – there's a lot of nostalgic memories that are a lot of pleasure to relive. So my advice is to pile those memories in and enjoy life. One day you'll be able to look back on it all with great deal of satisfaction.

My life motto? Do it your way.

JAY CHUDASAMA

78 YEARS BOLD

Jay Chudasama grew up in Kenya, where he worked with his father as a shoemaker. Today, he is a cobbler based in Brixton, South London.

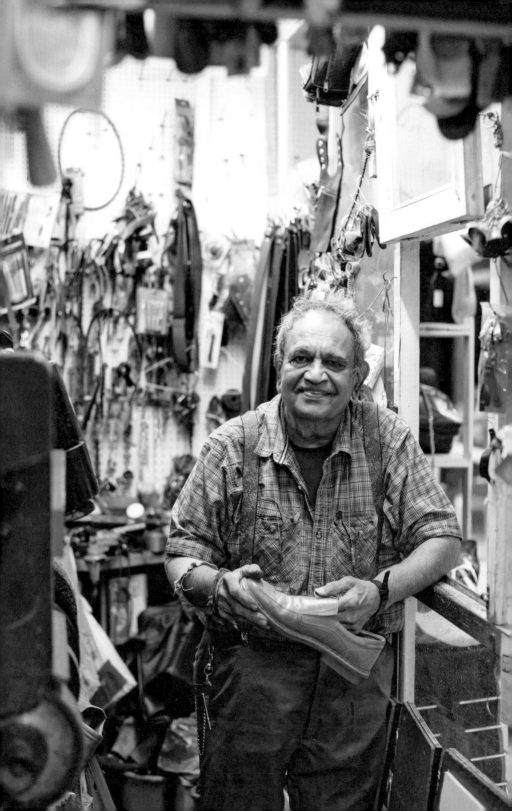

JAY CHUDASAMA

I WAS BORN IN KENYA and lived there until I was 30, when I decided to move to London with my wife and children. My father was a shoemaker, and I'd joined him in the trade when I was about 12. When I came to England it was too expensive to carry on as a shoemaker, so now I concentrate on shoe repair instead. I really enjoy it; my life has always revolved around shoes, and it keeps me connected to my father in some way.

I married my wife in 1968 – it was an arranged marriage, but we were both happy about it. We are still a very close family today. We see our children most weeks, and my son and three of our grandchildren all live with us, so we are a busy home of seven. Having them around helps to keep me young; all the grandchildren are under 10 and full of energy.

Having children changed me a lot, and I am so proud of them today. My son followed me into the shoe trade, while two of my daughters are now lawyers, one is a psychologist and another is a housewife. I don't look at my daughters any differently to my son – they all make me smile. I've learnt over the years that all you need is family to keep life happy.

Happiness for me is also working – if my customers have a difficult repair that they can't get done elsewhere, I really enjoy being able to get it sorted for them. I will spend time on it to get it done right: that sort of service can be hard to find these days. Life experience has made it easier for me to deal with customers over the years, although I do occasionally lose my cool.

"Death is coming, but it's not a problem."

I could have retired when I was 65, but I didn't want to sit at home; I wanted to carry on improving, so here I am. It's not to make money. I just think that if your health is OK, you shouldn't just say, 'Oh I'm old enough to retire, I want to enjoy myself.' You should try to do something to keep healthy. I am on my feet a lot of the day here – this is my exercise.

Diet-wise I eat everything I want, but I do try to avoid too much sugary stuff. I might have a pint every now and then, but sometimes a month will go by and I haven't had an alcoholic drink. Sometimes I take medicine from the doctor, and I have had things done to my spine, but I am not scared of anything. Death is coming, but it's not a problem. Everything is in the hands of God. I just want to live nicely and enjoy my family.

I was happy when I was young, but I am happy now, too. I have had bad times, but I've learnt from them. The best advice I've got? Don't get a credit card. Spend what you earn. I tell my children that all the time. Credit cards are a headache. If you must get one, pay it off immediately. So many people owe banks money, and then life becomes difficult.

Thank you

FIRST OF ALL, the biggest, boldest thank you to all the glorious interviewees who agreed to be featured in this book (and yet more who appear on our website). We literally couldn't have done this without you. Thank you for your time, your brilliant stories and your kind and honest words of advice.

Thank you to Kate Pollard at Hardie Grant for being an early supporter of Bolder and for agreeing to take a rather large leap of faith in publishing this book. You are clearly as wise as our subjects!

To our agent Alice Saunders at The Soho Agency who was our cheerleader right from the get go. Your energy and enthusiasm for Bolder has always been SO reassuring. Thank you for helping us believe in ourselves.

Sending super-powered thank yous all the way to New Zealand to our unnaturally talented designer (and completely adored friend) Julia Murray. We are so thrilled that we were able to create Bolder with you. We miss you.

To River Thompson, for agreeing to take our photo on the most blustery day of the year. To our subscribers and followers @being_bolder, for joining our conversations.

And to our friends and family, who have supported us and encouraged us since the beginning, when Bolder was not very old, nor very wise.

Published in 2019 by Hardie Grant Books, an imprint of Hardie Grant Publishing

Hardie Grant Books (London)
5th & 6th Floors
52–54 Southwark Street
London SE1 1UN

Hardie Grant Books (Melbourne)
Building 1, 658 Church Street
Richmond, Victoria 3121

hardiegrantbooks.com

British Library Cataloguing-in-Publication Data. A catalogue record for this book is available from the British Library.

Bolder by Dominique Afacan and Helen Cathcart
ISBN: 978-1-78488-256-3

Publishing Director: Kate Pollard
Junior Editor: Eila Purvis
Designer: Julia Murray
Photographer: Helen Cathcart
Copy editor: Sarah Herman

Colour Reproduction by p2d
Printed and bound in China by Leo Paper Group